JOSEPH RAPHAEL (1869–1950): AN ARTISTIC JOURNEY

JOSEPH RAPHAEL

(1869–1950)

An Artistic Journey

November 18, 2003 – January 3, 2004

Essay by William H. Gerdts

Catalogue introductions by Phyllis Hattis

Spanierman Gallery, LLC

www.spanierman.com

45 East 58th Street New York, NY 10022 Tel (212) 832-0208 Fax (212) 832-8114 gavin@spanierman.com

COVER:
Self Portrait (detail of cat. 37)

Published in the United States of America in 2003 by
Spanierman Gallery, LLC, 45 East 58th Street, New York, NY 10022.

Copyright © 2003 Spanierman Gallery, LLC.

Library of Congress Control Number: 2003113591

ISBN 0-945936-61-3

Design: Marcus Ratliff
Composition: Amy Pyle
Photography: Roz Akin
Imaging: Center Page
Lithography: Meridian Printing

ACKNOWLEDGMENTS

ABOUT TWELVE years ago, my father and I visited the scholar and art dealer Phyllis Hattis and saw a group of paintings by Joseph Raphael, many of which had been in the collection of the artist's descendants. Phyllis had long been working with Raphael's family, particularly his daughter, Johanna Raphael Sibbett, to create a catalogue raisonné of the artist's works. At the time, I knew little about Raphael. I was aware that he was born in San Francisco and that his works were treasured by California collectors. For these reasons, I presumed that he was a "California painter." I was surprised to discover that California scenes constituted only a small part of Raphael's oeuvre and those that survived were created mainly during the last decade of his life, after a career spent living in Europe. It was immediately apparent that his works stood apart from those of his Bay Area counterparts. Heavily impastoed and light infused, Raphael's vibrant canvases possess a unique sensibility and reveal a distinctive synthesis of many aspects of early twentieth-century modern European art.

In the years following my introduction to Raphael, art scholars have focused on the achievements of American artists abroad, and the careers of many forgotten painters have been illuminated. In the process, Raphael's name has become better known, yet his following continues to consist almost exclusively of Californians. An excellent exhibition of his work was held at Stanford University in 1980, but its catalogue was never published and his audience remained local.

In time, it became clear to us that Spanierman Gallery could provide the greater exposure and study of Raphael that was long needed and overdue. In fact, this is Raphael's first retrospective in New York. With thanks to the many generous lenders and with the collaboration of the catalogue raisonné, we have brought together works from all phases of Raphael's career, including paintings and graphic works produced in Belgium, Holland, and San Francisco.

This show and catalogue would not have been possible without the contributions of many people. First, and foremost I would like to express gratitude to those who have graciously lent their paintings, in particular Donna and Mort Fleischer; Dr. Donald Head; and Dr. and Mrs. Oscar Lemer. Museums have also kindly lent works and offered assistance. We are also thankful for loans from the Elizabeth S. and Alvin I. Fine Museum, Temple Emanu-El, San Francisco; the Fine Arts Museums of San Francisco; the Iris & B. Gerald Cantor Center for Visual Arts, Stanford University, California; the Monterey Museum of Art, California; and the Pasadena Museum of Art, California. I would also like to thank John and Joel Garzoli, Garzoli Gallery, San Francisco.

We are extremely grateful for the opportunity to collaborate with the artist's daughter Johanna, who has been devoted to chronicling the life and work of her father for decades. As the author of the forthcoming catalogue raisonné, Phyllis Hattis worked with us on every stage of this project as well as contributed essays introducing the catalogue plates. Professor William H. Gerdts is due our gratitude for his eloquent essay and astute counsel. We would like to thank Phil Linhares, chief curator of the Oakland Museum of California, for his introduction and Judith Hanson for copyediting the essay. I would also like to thank the following members of the Spanierman Gallery staff for their dedication to this project: Roz Akin, Bill Fiddler, Matt Fisher, Garth Freeman, Maria Harrison, Taylor Hughes, Amy La Placa, Jack Ming, Inbal Samin, Deborah Spanierman, Stephen Thornhill, and Christina Vassallo. Lisa N. Peters served as catalogue editor. Marcus Ratliff and Amy Pyle designed the catalogue with their usual care. As always, I am appreciative of my father, Ira Spanierman, for his wisdom and guidance.

Gavin Spanierman

WHERE DOES one start with giving thanks to all the people who have helped us in so many ways over a span of twenty-six years? In the present, when we are pleased to be collaborating with Ira and Gavin Spanierman and their committed staff, particularly Lisa N. Peters and Christina Vassallo, who have enabled us to produce this beautiful publication.

In the early stages of our research on Joe Raphael's work, we met the helpful and kind curators from the Bay Area, Phil Linhares, then curator of the Mills College Art Museum and today chief curator of Art of the Oakland Museum of California, who in turn directed us to Anita V. Mozley, then of the Stanford Art Museum. They gave generously of their time and knowledge so that we could advance our catalogue raisonné and preparations for this exhibition.

Over the years, we have been fortunate to work with an array of talented and engaged individuals: the late Professor Jean de Heinzelin and his wife, Pat Chandler, Carole Denninger-Schreuder, Lisa Farrington, Lissa Fesus, the late Mark Hoffman of Maxwell Galleries, Josselin Lifton-Zoline, Amy Lipton, Hélène Mund, Miranda Rock, Lynn Rogerson and Joseph Saunders of Art Services International, Alexia Hunter Seeger, Nina Smith, and Alina Trowbridge. Curators and conservators who stand out are Luca Bonetti, Betsy Fryberger, and James Pennuto. Those who participated with us beyond the call of duty include Margot Bowen, whose resourcefulness led to collaborating with Kitty Bliss on a documentary film of Joseph Raphael viewed through the eyes of his youngest daughter; Sandrine Moutarde, who with Damien Balay created our website; Julie Silliman with her ongoing input; and Marion Wild, whose exceptional skills continue to aid us today. To our families, friends, and Raphael collectors, we owe a heart full of thanks: Fred Altshuler, Sandor and Beth Burstein, Rinaldo Califano, Cecilia Chia, Mari L. Clements, Donald Delson, Bonnie Earls-Solari, Florence Hattis, Donald Head, Nina McElroy, Maryann Mullins, David Sibbett, Eric A. Sibbett, David Stone, and Elizabeth Varet. Lastly, to Beata Rubin, whose youthful wisdom accommodated us, and to William Rubin, whose knowledge, judgment, and experience cannot be measured.

Johanna Raphael Sibbett and Phyllis Hattis

FOREWORD

AFTER TWENTY-SIX YEARS of research and work on the Joseph Raphael project, it is with great joy that I am writing the foreword for this exhibition catalogue.

My thoughts often go back to the spring of 1950, when my late husband, Morgan, and I were having dinner with my father, Joseph Raphael. As so often, the conversation turned to his work and we would ask, "where is it now?" He seldom knew. That inspired us to search some day for all of his art and create a catalogue raisonné. When we told him about our plan, he was obviously pleased. But soon there was another reaction: "Don't do that, it will be much too much work."

He knew how much he had done over a span of more than fifty years. And we? We had no idea what that meant—a few years, maybe more? It didn't matter, we were determined to do it. So in 1977, after our children were grown up, Morgan and I started on our long journey to find his work, which took us to California for months at a time and also to Holland and Belgium, where we had lived between 1912 and 1939.

Now it's 2003 and so far we have found five hundred oil paintings, four hundred watercolors, two hundred drawings, one hundred etchings, four hundred and fifty black-and-white and color woodcuts, for a total of approximately 1,650 works. Still, new works show up at auctions and galleries. My guess is that there may be hundreds more, especially in Belgium, where we have found but a few.

So after all those years, it's wonderful to have just returned from a Joseph Raphael exhibition at the Monterey Museum of Art and to be getting ready for our exhibition here at Spanierman Gallery. I am grateful to Ira Spanierman and Gavin Spanierman and their staff for offering us this opportunity. My heartfelt thanks to Professor William H. Gerdts for writing the important essay in the catalogue. I am equally grateful to the art historian, Dr. Phyllis Hattis, my consultant and friend, who has helped me along over more than twenty years with good advice and involvement, including the use of several capable secretaries. I also want to recognize my dear late husband's initiatives in beginning this project with me. Unfortunately he got very sick and died in 1982, five years after we started. I still miss his input, but he would have been proud and happy with the results of all the years of work and of the two exhibitions this year. Our dream of finding my father's work and showing it to many is finally coming true.

Johanna Raphael Sibbett

INTRODUCTION

J OSEPH RAPHAEL (1869–1950) holds an honored place in the annals of California art, yet he spent thirty-seven of his most productive years in France, Belgium, and Holland. Born in San Francisco, he studied under Arthur Mathews and Douglas Tilden at the California School of Design before undertaking advanced studies at the Académie Julian in Paris. Immersed in the creative atmosphere of Europe, first Paris and Laren, the Dutch art colony, and later, The Netherlands. Raphael married a Dutch woman and remained longer than he originally intended.

Even while he was living and working abroad, his work was often seen in the San Francisco Bay Area due to the efforts of his friend, the prominent Californian art patron, Albert M. Bender, as well as his dealers and artist friends. Bender's career as an exceptional insurance agent was built up during and after San Francisco's disastrous 1906 earthquake and fire. He emerged as a major benefactor of the region's museums, libraries, and schools, all the while attending to Raphael's artistic presence. He placed Raphael's paintings in all the major local exhibitions, including the San Francisco Art Association's annuals through 1939 and the 1915 Panama-Pacific International Exhibition, where Raphael won a silver medal.

For California artists and institutions, the exposition was a watershed event. For many visitors it provided a first glimpse of French and American Impressionist paintings; it inspired the local "Society of Six," a group of Post-Impressionist painters, including William H. Clapp, who knew Raphael in Paris in the early 1900s. Clapp, who served as curator of the Oakland Art Gallery (now The Oakland Museum of California) from 1918 to 1949, wrote in his journal of October 5, 1939: "In my opinion, Raphael is the greatest artist California has produced; in fact, he is close to being the greatest Impressionist that the whole nation has produced."

As often happens, the public's attention and enthusiasms dim in the decades after an artist's death. Despite his respected place among artists in both California and Europe, little has been seen of his work until recently. Revival of interest in Raphael's work is due in great part to the devotion and persistence of his daugher, Johanna Raphael Sibbett, originally accompanied by her late husband, Morgan. It has been her enduring wish to see her father's contributions recognized and appreciated. The recent exhibition, *Joseph Raphael, American Expatriate, Impressionist Paintings from the Collection of Oscar and Trudy Lemer*, at the Monterey Peninsula Museum in summer 2003 and this exhibition provide a fresh view of the vibrant paintings that caused an earlier generation to honor the artist Joseph Raphael.

Philip E. Linhares, Chief Curator of Art, The Oakland Museum of California

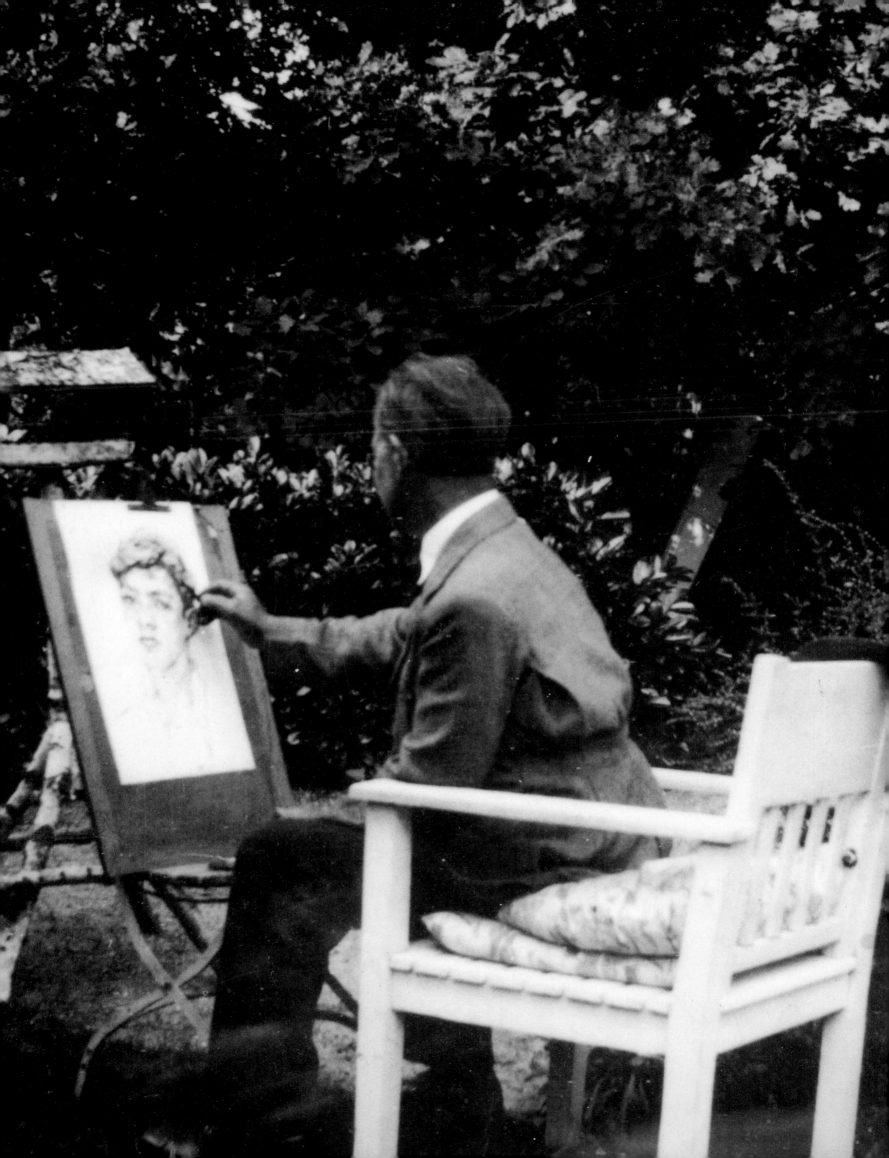

JOSEPH RAPHAEL (1869–1950): AN ARTISTIC JOURNEY

William H. Gerdts

JOSEPH RAPHAEL was one of the most accomplished and innovative artists to emerge from California.[1] Over the course of several decades, his art went through an amazing evolution, an artistic journey through many stylistic phases. He worked first in a naturalist vein and then, more spectacularly, as a master of Post-Impressionist and Expressionist strategies. At their finest, his achievements vie with any of those of the best American painters of his day.

Despite the significance of his work, a full study of Raphael's art and career has not previously been attempted, although many factors suggest that he would be an ideal artist for a scholarly exploration. His children and other family members have provided their reminiscences of him. A substantial number of the works that he created over the course of more than half a century—including oils, watercolors, drawings, and woodcuts—have been catalogued. However, a consideration of Raphael's professional development and oeuvre poses immense challenges. Indeed, there are so many puzzling questions about the artist and his work that this exhibition's alternative title could readily be *The Elusive Joseph Raphael*.

The first challenge is the lack of scholarly attention given to the artist. Although Raphael's work was and is greatly acclaimed and sought after by California collectors, it is largely unknown on the East Coast. Since the artist's death in 1950, until last year, there have been no published monographic studies or serious catalogues devoted to his accomplishment.[2]

The second difficulty resides in the relative paucity of other documentation of Raphael's life and art.[3] We are fortunate that one rich trove of letters exists—the correspondence from 1909 to 1939 between Raphael and his principal Bay area patron, Irish-born Albert Bender of San Francisco[4]—but there is a dearth of material on Raphael documenting the decades he spent abroad and those between the two World Wars.

Yet a third and even greater enigma plagues the study of Raphael. Although his art reveals that he was a tremendously professional artist who was eager to explore a variety of modernist directions, there is little evidence so far of his interaction with contemporary American, French, Dutch, or Belgian artists. He painted in Holland and Belgium for thirty-five years, but he did not submit his work to exhibitions in those countries (with the exception of a few small shows of his woodcuts held in

Fig. 1.
Photograph, Joseph Raphael, Oegstgeest, Holland, ca. 1932, courtesy of Johanna Raphael Sibbett.

Brussels in the 1920s and participation in minor venues in Holland in the 1930s), and he was almost never mentioned in Low Country art journals. In addition, Low Country artists were singularly silent on Raphael in their letters and diaries.

Raphael is believed to have been a good family man, a faithful husband and loving father. Almost surely he would have been a desirable neighbor, but if he was remembered as such, no record appears to have been preserved. If he associated with other artists in either Belgium or Holland, whether on the national scene or in more local associations, almost no account of such involvement—professional or social—has survived. One explanation here, but certainly a partial one, is that Raphael always considered himself an American artist, and he was very aware that the Bay Area provided a substantial, if insufficient, market for his art.

Early Life and Career

Raphael was one of the few modernist artists of the early twentieth century who was actually a native of California, though (as with Guy Rose, the other best-known California painter of the time) his maturation took place abroad. The first of four children, he was born on June 2, 1869, on Minna Street in San Francisco, the son of Nathan Raphael, a Jewish tailor originally from Poland, and his wife, Elizabeth, née Moses.[5] Joseph's first employment was at a store in the city. He then washed gold in Amador County before working at a trading post in Arizona. About 1887-88 Raphael began to take night classes with two local San Francisco artists, Christian Jorgensen and Solly Walter. In 1893 he enrolled at the California School of Design (now the San Francisco Art Institute), run by the San Francisco Art Association, which that year moved to the Mark Hopkins mansion on Nob Hill (in the years that followed, the association's exhibitions were held commemoratively under the aegis of the Mark Hopkins Institute).[6]

Unlike the art of southern California, where Impressionism found warm reception in Pasadena, Laguna Beach, and San Diego, the art of northern California at the end of the nineteenth century was dominated by the Tonalist aesthetics that characterized the work of the San Francisco painter Arthur Mathews. Mathews had studied at the Académie Julian in Paris and exhibited frequently at the Salon before becoming director of the San Francisco School of Design in 1890 (renamed the California School of Design in 1893). His most ambitious works were painted in a subtle, closely toned mode, often utilizing decorative, Art Nouveau outlines. While attending the school from 1893 to 1897, Raphael studied with Mathews and with the sculptor Douglas Tilden.

In 1894 Raphael won the W. E. Brown gold medal for drawing from life from the Hopkins Institute, and in 1897 he received the James E. Phelan gold medal for

modeling from life. He probably exhibited his first painting in September 1895, when he contributed to the show of the State Agricultural Society, held in Sacramento. The following year he began to display his work at exhibitions, both at the school and in the annuals of the San Francisco Art Association. He exhibited *A Mother* (ca. 1895; location unknown) at the association's winter show at the Hopkins Institute in 1895–96. In 1898, he displayed *The Horse-shoer* (later entitled the *Blacksmith's Shop*) (ca. 1898; location unknown) in another of the association's winter shows. This painting was lent to the show by the painter Mary T. Menton (wife of William Henry Menton), who in 1898 probably became Raphael's first patron.[7]

In 1900 he sent two paintings, *Amador* (ca. 1900; location unknown) and Mrs. Menton's *The Horse-shoer*, to the spring exhibition of the association. Even during his student years, Raphael's work did not go unnoticed. One critic reviewing the 1900 exhibition noted that "one of the younger men has already arrived—Joseph M. Raphael. . . . Raphael has been crude at times, but there was enough originality about his work to attract attention even when he was not understood."[8]

Paris and Laren

In 1903 Raphael went to Paris, where he continued his studies at the Académie Julian under the celebrated painter Jean-Paul Laurens. In Paris, where he gave his address as 31, rue du Dragon, Raphael also joined a group of American artists who met in the studio of the Pittsburgh painter Arthur Sparks on the rue Vercingétorix or in that of the Canada-born and California-raised William Clapp (above Sparks's studio); both Sparks and Clapp were also students of Laurens. At about the same time, Raphael began a pattern, one that he would continue for approximately nine years, of dividing his time between Paris and the artists' colony in Laren, Holland, perhaps the most vital of the many similar colonies that developed in the Netherlands before and after the turn of the twentieth century. Raphael first visited Laren on July 29, 1903, where he resided at the Pension Kam, also known as "The White House" or the "English Pension." Raphael's presence there is mentioned again on June 20, 1906. In Laren, Raphael probably fell in with the foreign artists active there during the decade, many of whom stayed at the Pension Kam, though they found barns and other building to utilize as studios. He would probably have known Alida Ghirardelli from San Francisco, who was at the Pension Kam at the same time.[9] On other occasions, Raphael resided at the Laren farmhouse of the van Eiden family, along with fellow San Francisco artist, Ralph Mocine.

A sense of Raphael's activities during these early years can be gleaned from the correspondence of Albert Krehbiel, an art student from Newton, Kansas, who had previously studied at the School of the Art Institute of Chicago, to his former fellow

student and future wife, Dulah Evans.[10] Krehbiel was also in Laurens's class at the Académie Julian, and the two were good friends during this period. They worked together, both in Paris and Laren. In her reminiscences of Laren, the English artist Laura Knight singled the two out for their prowess at baseball, which provided relaxation from their artistic efforts.[11] Raphael and Krehbiel, along with four of Laurens's other students, traveled to Italy in the late spring of 1905. There they visited Rome, Pisa, Florence, and Venice. They returned to Laren and were back in Paris in November to attend classes at Julian's. In March of 1906 Raphael and Krehbiel took a week to explore the landscape around Barbizon and the Forest of Fontainebleau, accompanied by Wilder Darling, a painter from Toledo, Ohio.

Immediately thereafter, in early April, Raphael and Krehbiel took a fifty-seven hour train trip to Madrid, where they stayed at the Pension Carmona, which had earlier housed William Merritt Chase and John Singer Sargent. Like these painters and so many other European and American artists, they expressed great admiration for the work of Velásquez they viewed at the Prado Museum in Madrid. The following month, on May 13, 1906, Raphael organized the farewell dinner in Krehbiel's honor before the latter returned to Chicago, where he joined the staff of the Art Institute School. Krehbiel went on to establish a reputation for himself as a leading Midwestern Impressionist painter and muralist.[12]

At this time, Raphael's art fell into the popular naturalist school. Much of it was devoted to the peasant genre, and he painted primarily indoor scenes of the daily activity of his farmer neighbors in Laren, the Schaapherder and de Leeuw families, including *Interior with Women and Children, Laren* (1903; private collection). In these works, he stressed familial and maternal relationships, often among the impoverished. Such works reflect the direct influence of one of the most renowned Dutch peasant genre painters, Albert Neuhuys, a disciple of the internationally famous Josef Israels. Neuhuys lived and worked in Laren, and his paintings were also celebrated and much patronized in the United States.[13]

Raphael began to show his work at the Paris Salon in 1904, but he was soon to gain acclaim for two monumental group portraits he painted in 1905. In her memoir, Knight reports that Raphael "was just then at work on a phenomenally big canvas for the next Salon; the subject peasant merry making,"[14] probably a reference to *La Fête du Bourgmestre* (Cat. 1), in which Raphael portrayed the mayor (the *Bourgmestre*) of Laren at the anniversary of his five or ten years in office, an event that was celebrated like a wedding anniversary in which honors and gifts were bestowed. This painting brought the artist considerable critical acclaim. It was included in the 1906 Paris Salon, where it received an honorable mention.[15] It was then sent to the United States, where it was shown at the Art Institute of Chicago that October; it was again exhibited at the 1909 annual at the Pennsylvania Academy of the Fine Arts. In 1910,

when the painting was included in Raphael's one-artist exhibition, held at the San Francisco Institute of Art, it was identified more specifically as *The Burgomaster Captain W. N. Van den Brock Entertains His Friends*. Purchased from the show by a group of San Francisco patrons, it was presented to the San Francisco Art Association in 1911. At the time, Raphael himself considered the painting to have been the most successful of those he had thus far created.[16]

In 1906 Raphael Weill, an important San Francisco businessman (he owned the White House Department Store) and supporter of the arts, purchased the artist's group portrait *The Town Crier and His Family* (Fig. 2). The work had been shown at the Société des Arts Français in Paris and then at the Art Institute of Chicago in October of 1905; in 1906 it was lent by Weill to the San Francisco Art Association for their annual, where it was identified as *The New Town Crier*. Fortunately, it survived the 1906 earthquake and fire that destroyed so many great art treasures at the Mark Hopkins Institute.[17] After showing the painting first at the Girls' Club and then at the Bohemian Club, both in San Francisco, Weill donated it to the M. H. de Young Museum (now the Fine Arts Museums of San Francisco) in 1908. The work gained tremendous encomiums in the San Francisco press. In the *San Francisco Call*, Laura Bride Powers deemed it "great," noting the influence of both Rembrandt and Josef Israels and concluding that "no such picture has fallen under my gaze in many moons, and there are those whose opinions are far worthier than mine who proclaim it the best picture ever done by a San Franciscan."[18]

Both group portraits hark back to those created by Frans Hals and others in seventeenth-century Holland. Indeed, one Parisian critic likened *La Fête* to Rembrandt's *Night Watch* (1642; Rijksmuseum, Amsterdam).[19] At the same time, the dark dramatic tones of the works, accentuated in the costumes of the principal figures, present a strong naturalist drama that would seem to characterize the local townspeople with whom Raphael and his fellow artists in the Laren colony were interacting. But there appears to be more happening in these paintings, some of it slightly disconcerting. The figures are looking out directly at the artist and the viewer—almost as if posed for a photograph, one of immense proportions. And yet the reactions of the principal figures in *La Fête* range from the smug self-assurance of the top-hatted Bourgmestre (identified as Captain W. N. Van den Broek), to the sullen expressions

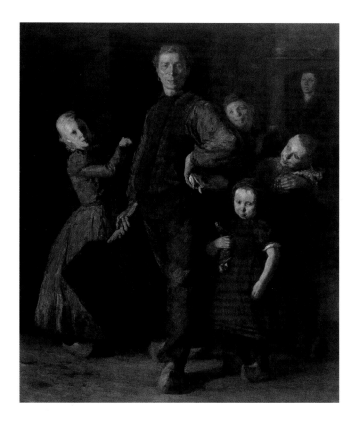

Fig. 2.
The Town Crier and His Family, 1905, oil on canvas, 78 × 64⅝ in., Fine Arts Museums of San Francisco, Gift of The Honorable Raphael Weill.

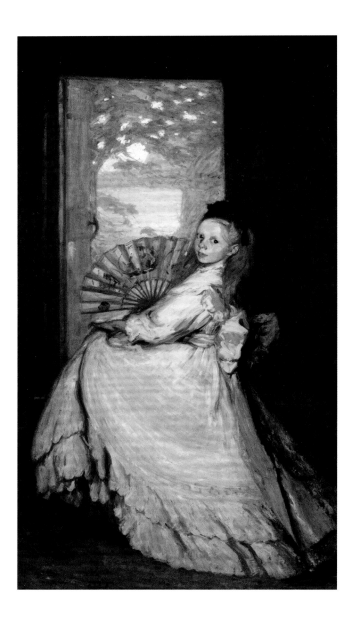

Fig. 3.
Girl with a Fan, 1907,
oil on canvas, 90 × 65 in.,
Mills College Art
Museum, Oakland, Gift
of Albert M. Bender.

of some of the other adult men, to the suspicious glances of the younger folk.[20] With so many figures in a darkened, unwindowed room, there is a sense of claustrophobia, which is alleviated by the principal young woman in white, who holds a basket of fruit. This cornucopia extends beyond her almost dancing form, largely relieving the tension of the group portrait.

Even more dramatic is Raphael's *The Town Crier and His Family*, sometimes referred to as the *Town Crier's Family*. Here the title figure stands rigidly but self-consciously in the exact center of the canvas, stretching from floor to ceiling, with the rest of the members of his family clinging to him and establishing the "oneness" of the household. Similar and even more intense than *La Fête*, the strong studio lighting reveals all the details of costume and physiognomy. The face of the town crier is minutely detailed in the manner of the fifteenth-century Flemish masters that Raphael may have studied at the time.

These two masterworks aside, Raphael continued to create works in the peasant genre, sometimes of a gentle and poetic nature, as in his *Blue Chest* (1911; private collection). But he also introduced a streak of symbolism into some of his canvases; the young women in both *La Fête* and the *Town Crier*—in which the subject's daughter at the left assumes a strange, slightly coquettish pose—prefigure his monumental *Girl with a Fan* (Fig. 3). In this painting, the young woman looks back over her shoulder at the artist and the viewer with an enigmatic expression, as she seems to head toward a doorway through which she may—or may not—exit. She wears an extravagantly elaborate dress—adult finery enhanced by a huge purple bow in back—and holds a large Japanese fan, which continues the sweep of her gown, creating a compositional semicircle that almost encompasses her. Beyond the doorway is a stylized landscape that seems both naturalistic and screenlike.

Raphael's fascination with young people took a different form in *Children Dancing along a Canal* (1907; private collection), a neutral-toned scene where, in an open square fronted by distinctly Dutch houses, the stylized movements of a group of children appear to support two dancing figures who receive the greatest light and

richest coloration. The viewer is left to question whether the scene is a ritual performance or a spontaneous outburst of juvenile activity. For all the monumentality of these paintings and their success in San Francisco, no notice of Raphael seems to have been taken of him by Dutch writers, nor are there records of his exhibiting his work in Holland.

Raphael's first decade of painting in Holland was marked by his absorption with naturalistic canvases, often involving both traditional subject matter and strategies and sometimes looking back to Dutch Old Master precedents. However, by the end of that decade he began to explore more advanced approaches. This may be seen especially in the small canvases he created out of doors that portrayed the younger members of the de Leeuw family, such as *Mien de Leeuw* (Cat. 2).

There is reason to think that Raphael had been impressed by the tremendous interest in such advanced tendencies developing in Holland at the time, one that was demonstrated by the Dutch fascination with their deceased native son, Vincent van Gogh, whose work was the subject of a major exhibition held Amsterdam in July–August 1905. Certainly, other foreign artists resident in Laren, in whose circle Raphael participated—such as Darling and the British painter, Laura Knight—were excited, if somewhat perplexed, by van Gogh's art.[21]

Perhaps equally significant was the temporary residence in Laren in 1909 of one of the earliest of the Dutch Modernists, Jan Sluijters. It may be that the presence of the young Sluijters helped Raphael to become more at ease with the investigation of more avant-garde strategies, which eventually allowed him to absorb the modernist innovations he had witnessed at the van Gogh exhibition four years earlier. (Raphael's daughter, Johanna Sibbett recalled her father poring over a book on van Gogh later in his career as carefully and intensely as a Bible.)[22] In any case, works by Sluijters, such as his *Boschlaantje* (1910; Kunstgalerij Albricht B. V. Velp) and *Landschap* (1910; Stedelijk Van Abbemuseum, Eindhoven, Holland), are radically more expressive than the artist's earlier work and closer in their use of blocklike strokes and surfaces to the artistic direction that Raphael's painting was about to take.[23]

The year 1909 also marked Raphael's earliest known correspondence with Albert M. Bender, who was a major force in the contemporary Bay Area art world and one of the most important champions of modern art in California.[24] He was a leading patron of contemporary art in San Francisco and a cousin of one of that city's foremost modernist painters, Anne Bremer.[25] The extant Raphael-Bender correspondence offers the greatest insight that presently exists into Raphael's subsequent career. Bender was to become both Raphael's primary patron and a close personal friend over the next thirty years. He may have inspired Raphael's return to San Francisco in 1910, where, during an eight-month stay, the artist's work was exhibited in his first one-artist show. That exhibition, referred to as "The Dutch Series," took

place in February at the San Francisco Art Association. It presented forty-five figural works by Raphael, centering around his monumental *Bourgmestre*, and included studies, sketches, and caricatures made in Holland and Paris. In April, three of Raphael's works were exhibited in the annual spring exhibition of the association.[26]

From Laren to Uccle

After leaving San Francisco in the fall of 1910, Raphael visited Mexico. He then spent time in New York and Havana before returning to Laren at the end of the year. He wrote to Bender in the spring of 1911 that he had "four months of extremely profitable work" in the atelier of his friend, "Mr. Darling"—the aforementioned Wilder Darling, was one of the leaders of the American contingent in Laren.[27] But Raphael soon found the environment "sickening."[28] This feeling was heightened after his May 29, 1911 marriage to Johanna Jongkindt, a Dordrecht-born pianist who had a three-year old daughter, Catherine. In January 1912 the family moved to the rue de la Station 68 in Uccle, a suburb of Brussels. They occasionally revisited Laren in the subsequent months, their last stay occurring on April 12.

The year 1911 was probably the most crucial year of Raphael's life. About the time that he married in May, he began to reform his artistic methodology and ideology, working out of doors and painting luminous portraits and then landscapes. He was becoming one of the most original and advanced artists of his generation to emerge from the West Coast of the United States. Although they are not typical of his primary aesthetic concerns, two paintings best illustrate the changes that occurred in Raphael's art: his self portraits of 1910 (Fig. 4) and 1916 (Cat. 36). The former, although already boldly and vigorously painted, is still a naturalistic representation of the artist, a straightforward rendering of an assured individual. Wearing a dark coat, he is posed against a neutral background, his flesh tones light and glowing. In the self portrait painted six years later, his image seems to burst forth. The face is constructed of patches of colors that exist unmelded upon the surface, while the background remains untouched. The former is a finished likeness; the latter, a constructed work of art.

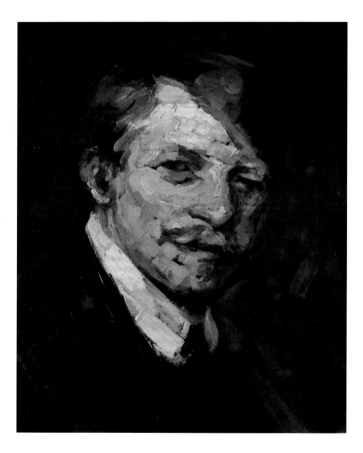

Fig. 4.
Self-Portrait, 1910, oil on paperboard, 16¼ × 13 in., Garzoli Gallery, San Rafael, California.

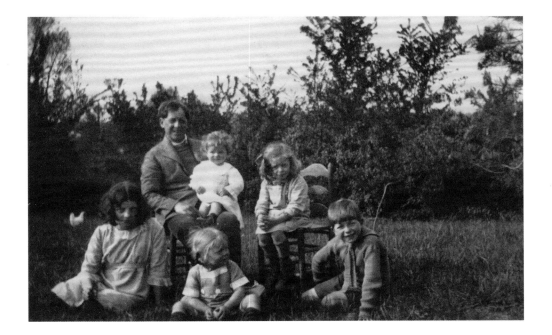

After tiring of Laren, and perhaps of the traditions of an artists' colony often steeped in peasant genre, Raphael and his family chose to remain in Belgium until 1929. The family would grow to seven, including four daughters and one son (Fig. 5). About 1911–12 Raphael began to send regular shipments of paintings to Bender who, beginning early in 1912, arranged for them to be exhibited and sold through the Helgesen Gallery at 285 Sutter Street (later 345 Sutter) in San Francisco, probably the most advanced commercial art enterprise in that city in that decade. In addition to having on hand Raphael's paintings and etchings, a medium that he seems to have begun to investigate at this time, Helgesen held one-artist shows of his work from time to time.

Yet money was tight in the Raphael household even after he began to sell his art at Helgesen's. In 1914 Bender attempted to lure Raphael back to California, and Raphael considered the proposition, especially after weeks of unrelieved gloomy weather. Even in August of 1914, when Germany invaded Belgium and World War I began, the Raphaels remained. Joseph purchased land and built a small house on the rue Engeland, in Kriekeput (Dutch for "Cherry Valley"), just south of Uccle. There he had views—southeast to Linkebeek Village, which would figure so often in his art, and Papakasteel (the "Pope's Castle"); and west to a local landmark. Papakasteel appears through the trees beyond the local stream in one of Raphael's most expressive and mature works of about 1915, *By the Stream (Papekasteel, Uccle, Belgium)* (Cat. 18), a nearly monochromatic image where the monumental blockiness of the structure is replicated in the squared brushstrokes that define the foliage at the right and the sharply repeated diagonals of the foreground plane. Raphael's Kriekeput house was a very small one, but his painting conditions improved somewhat with

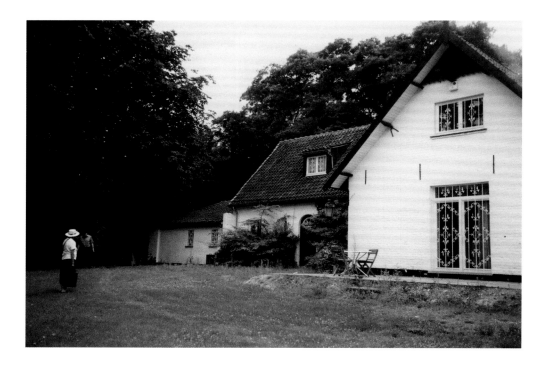

the addition of a wing, an atelier where he could paint and prepare his prints in solitude (Fig. 6).[29]

Although he also painted urban market scenes in Brussels, Raphael found the works that he painted in Uccle, Kriekeput, and on trips back to Holland tremendously satisfying. He wrote Bender: "Here I work every day, landscape. I'm painting the four points of the compass, the hottest sunny days preferred. It's like California."[30] He also noted to Bender in 1912: "With my work I have experimented and really studied and progressed not in the way of doing big things (it's not in me) but in the outdoor work."[31] With Bender's encouragement, patronage of Raphael's work was brisk, especially among the large Jewish community of the Bay Area, which included a great number of the region's cultural leaders. Many still treasure the Raphael paintings their families acquired during the early twentieth century.[32]

It must have been just about the time of his move to Belgium that Raphael's methodology changed radically. He began to paint colorful outdoor scenes, sometimes including figures and often set in fields of flowers and vividly rendered gardens. Raphael applied paint in large dabs, creating decorative Post-Impressionist tapestries. Frequently he flattened space and simplified forms, utilizing structural concepts related to the art of Paul Cézanne. At the same time, his tendencies also involved pointillist brushwork inspired by the art of Georges Seurat. His approach related to the heightened colorism, simplification, and decorative patterning of Paul Gauguin and van Gogh; the latter was the Post-Impressionist with whom he shared the greatest affinity. Van Gogh's influence is particularly evident, both directly and indirectly, in Raphael's *The Potato Diggers* (Cat. 27), one of a number of paintings of

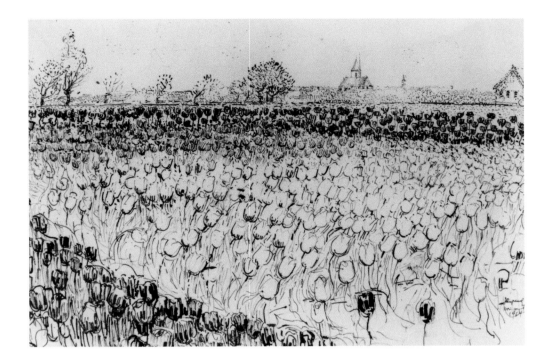

Fig. 7.
*Tulip Fields at
Noordwijk*, 1914,
pen and ink on paper,
14½ × 22¼ in.,
Oscar and Trudy Lemer
Collection.

peasants working outdoors. The vivid brushwork and intensely variegated colorism relate very much to those of the great Dutch modern master. At the same time, *The Potato Diggers* reveals a very conscious updating of the outdoor peasant work of the earlier French painter, Jean-François Millet, whose work had previously inspired van Gogh so greatly.

The effect of van Gogh's art on Raphael is also apparent in the latter's ink drawings. In these drawings, a dramatic use of varying densities of ink, as seen in the different ranges of Raphael's *Tulip Fields at Noordwijk* (Fig. 7), and a broken, angular calligraphy that varies from thin to thick, evident in his *Court of an Old Inn* (*The Old Lamp*), *Uccle* (ca. 1916; Mills College, Oakland, California), evoke van Gogh's graphic handling. The stippling method of Georges Seurat and Pointillism was not, of course, unknown in the Netherlands. It was practiced, for instance, by the relatively short-lived Ferdinand Hart Nibbrig, who resided in Laren until 1907—although that artist applied this aesthetic more to vast scenic landscapes than to flowering fields.

Nibbrig's work, which was closer to the Pointillism of Seurat than to the mosaic patches of Paul Signac, had found little favor in Holland. The second phase of Pointillism—inspired by Signac and practiced by Sluijters, Leo Gestel, Piet Mondrian, and Jan Toorop—was better received in the Netherlands. It is this approach to Pointillism that Raphael adopted. Thus he may well have been influenced not only by the work of van Gogh, but also by that of these Dutch Modernists. These so-called "Dutch luminists" wanted to paint light, some with small brushstrokes, some with larger. The exhibitions of their work at the Society of St. Luke at the Municipal Museum of Amsterdam between 1908 and 1910 were among the highlights of modern

art in Holland at the time and may well have had a direct impact on Raphael, who adopted strategies similar to theirs within a few years. By then, however, Raphael was already living in Belgium.[33]

With his work being exhibited at Helgesen's, Raphael's abrupt aesthetic change did not go unrecognized by San Francisco critics. Anna Cora Winchell, writing in 1916 for the *San Francisco Chronicle*, noted that "he passed rather suddenly from a style of work considered to be most conservative and dignified—not to say gloomy.... His transformation was rapid, however, and Raphael fell quickly and easily into the present-day type of work by which he is now distinguished as completely as he was by the older regime." By that time, actually, Raphael had turned to an even more Expressionist aesthetic as we shall see, and Winchell noted that "this latest work of Raphael shows him as expressing his most vital color sense, which, in some canvases, is fairly palpitant."[34]

Although resident in Belgium, some of Raphael's best-known paintings of the early 1910s were created on visits back to the Netherlands. Certainly in part because he was directing his concerns to rural themes, he painted often in the vicinity of Noordwijk, near his wife's hometown of Dordrecht, in southern Holland. He also painted the urban scene, and Uccle and Brussels offered him subject matter appropriate for his avant-garde strategies.

As his art developed during the second decade of the century, Raphael used paint ever more expressively, to the point where he may be said to have "jumped" from the Post-Impressionist canon to Expressionism. He produced his most celebrated paintings from 1910 through 1915–16. Each masterwork from this time has its own specific character, but it is difficult to determine the period's chronological development. Raphael appears to have approached each scene as a separate challenge. Sometimes he chose to balance two- and three-dimensional patterning over a broad swathe of territory as in *Pond with Flowering Trees (Belgium)* (Cat. 13), one of the artist's most fully Impressionist paintings. At other times he zeroed in on a more intimate section of his own home garden (Cats. 30–32).

One of Raphael's best-known works from the early 1910s is *Tulip Field in Holland* (Cat. 7). Here the character of the individual blooms are suppressed in favor of a broad sweep of floral carpeting, curving from the distant horizon of yellow, orange, and vermilion blooms to the somewhat darker violet and red tones closer to the foreground that contrasts with the narrow light sandy path at the left. Raphael's *Tulip Fields at Noordwijk (Holland)* (Cat. 5) offers a more varied pattern of dots of variegated colors to indicate the flowers that are ranged in rows in the lower half of the canvas, while the upper field leads back to a farmhouse, beyond which lies the horizon. Again, as in *Tulip Field in Holland*, the high horizon allows a dynamic rush of color to descend to the foreground. While such paintings share the freedom and coloration

of the Impressionist aesthetic, their dotted application of paint and more decorative assembly of colors and forms place them equally within a Post-Impressionist direction and suggest an amalgam of van Gogh's dynamics, the prevailing taste for Impressionism (especially in garden scenes), and the Post-Impressionism of Seurat, Signac, and the Pointillists, which had received even greater reception in Belgium than in France. Created a few years later, *Flowering Fields, Noordwijk (Holland)* (Cat. 8) evinces a more broken pattern of brushstrokes; it contrasts dark trees and a house on the dark blue hillside with swirling cloud patterns in the sky that prefigure the changes to occur in Raphael's painting in mid-decade.

Although tulips might quite obviously dominate Raphael's images of broad fields of flowerbeds, other blooms were chosen by the artist as well. One of the most beautiful, as well as one of the most abstract of these is his *Hyacinth Fields* (1912; private collection), a rectangle of light-colored flowers separated from the similarly toned sky only by the fringe of village buildings on the horizon. That same emphasis on geometric abstraction characterizes the more colorful *Tulip Field and Noordwijk Village* (ca. 1913; private collection), where the strict layout of the flower beds contrasts with the broken forms of the town's red brick buildings in the distance. One of the most unusual of this group is Raphael's *Children on Beach* (1914; private collection), which portrays a relatively colorless expanse of field, where a group of four young girls add the dynamics of their children's game deep in the lower right corner to an otherwise static, near-abstract composition. Both contrasting with and reflecting Raphael's earlier treatment of a similar theme in his 1907 *Children Dancing along a Canal*, here his broader brushwork prefigures his later developments.

Not all of Raphael's flower paintings from this period are panoramic. In *Tulip Field in Holland*, he concentrated on a single vivid red field, with a burdened peasant figure emerging from the woods at the left. Raphael also enjoyed the play of the patterns created by flowering trees set within colorful landscapes, such as in the aforementioned *Pond with Flowering Trees (Belgium)* (Cat. 13). The patterning of flowering trees appealed to Raphael almost as much as those of fields of flowers, scenes in which he often interjected a more personal and domestic note. This is true of his *Fields and Flowering Trees (Noordwijk, Holland)* (Cat. 6), where the right-hand section of the composition reveals a group of impressionistically rendered trees. Below is a figure of a woman, standing in front of a modest dwelling and looking over the fields, who casts rich, blue shadows. Toward the left are more fields, vast and unbroken, reaching to the distant horizon.

The great expanse of *Fields and Flowering Trees (Noordwijk, Holland)* captures the vast fields of Noordwijk, which appealed so much to Raphael. But he may also have settled down to paint the local landscape more often, particularly in those works in which he concentrated not on the flowering fields but on the fruit trees that

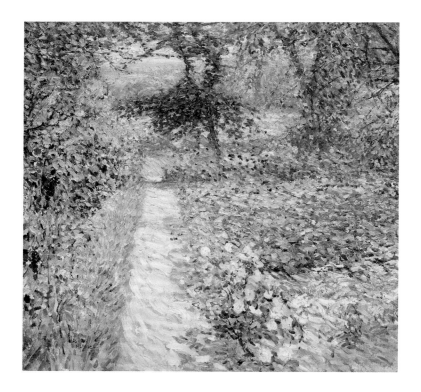

Fig. 8.
The Garden Path,
ca. 1913–15, oil on
canvas, 28 × 30 in.,
Garzoli Gallery, San
Rafael, California.

may have been cultivated nearby. There is a whole host of these images, in which one or two trees dominate, their outlines breaking against the mass of daubs of paint that represent their full flowering: *Amidst Flowering Trees (Belgium)* (Cat. 14), with the trees at the left, and *Flowering Fruit Trees (Belgium)* (Cat. 15), with the trees at right and center. Color is not a major element in such pictures, as it is in *Pond with Willow Tree (Belgium)* (Cat. 17), where the trees at the right overhang the glistening pond water, itself reflective of the pale lavenders of the distant shore.

One of Raphael's most beautiful, and perhaps most clearly Impressionist, works is *The Garden Path* (Fig. 8). In this paean to the beauty of cultivated, intimate nature, a light-reflecting path divides a garden that is made up of hundreds of fragments of multicolored brushwork. A pathway likewise bisects the composition of the *Artist's Home, Rue Engeland, Uccle* (ca. 1914; private collection). Here the path is overlain with shadows cast by the flowers and bushes that line it, while the composition is dominated by the small, whitewashed building that housed his family.

During the early 1910s, Raphael's work was frequently exhibited in his home state. Organized by Bender, his first show of the decade was at the Helgesen Gallery in 1912. Raphael's second show at Helgesen's opened in late March 1914 and included one hundred and eight works. Michael Williams reviewed it the *San Francisco Examiner*: "The open-air paintings ARE open-air; they vibrate with sunshine and are steeped in atmospheric color."[35] That year, one of California's leading art critics, Everett C. Maxwell wrote: "How the San Franciscans do worship Joseph Raphael! And he truly deserves it for he is indeed and in truth a great figure painter."[36] In the following year, Raphael was awarded a silver medal at the Panama-Pacific International Exposition in San Francisco, where six of his paintings were exhibited. In 1916 he won the First Purchase Prize from the San Francisco Art Association for *The Garden Path*. That year Helgesen's again held a spring exhibition of Raphael's art. In a review of the show, the critic for the *Oakland Tribune* praised the artist's Dutch and Belgian scenes for a "vividness that makes the picture bring before the beholder the beauties of the original gardens. Raphael revels in color, and his themes are chosen largely for their radiant qualities which he paints with splendid force and convic-

tion."[37] Raphael continued to send works back to San Francisco in the years that followed, and Bender continued to send him checks in return.

The impact of the paintings Raphael exhibited in San Francisco in the early and mid-1910s on the younger, more avant-garde artists of the Bay Area is a subject worthy of further research. In 1947 William Clapp, the longtime director of the Oakland Art Gallery, recollected to Dr. William Porter: "In 1917 when I returned to California after many years absence, Joe was practically idolized by the younger generation of painters, an idolatry that continued until the ultra-modern movements gradually replaced Impressionism."[38] In 1939 Clapp had even stated: "In my opinion Raphael is the greatest artist that California has produced (In fact he is close to being the greatest Impressionist that the whole nation has produced)."[39] The scholar Nancy Boas, who specializes in the work of the Society of Six, the advanced Bay Area group of the 1920s, interviewed Louis Siegrist, the surviving member of the group on July 23, 1983. It would seem from Siegrist's comments that even members of the Society found some inspiration in his work, especially in the high-key colorism of his art.[40]

Raphael's works of the early and mid-1910s are certainly among the best remembered of those created during his long expatriation abroad. Even as late as 1935, long after Raphael had turned to alternative aesthetic modes, a San Francisco critic stated that the artist was "an impressionist who sticks to his guns—in other words his sunshine and open air atmospheric studies."[41]

Perhaps because Holland was a neutral country in the First World War, Raphael was less able to travel there from occupied Belgium than before the war. He therefore turned away from the portrayal of the fields of flowers near Noordwijk, concentrating instead on the local Belgian landscape in colorful scenes such as *Fields near St. Job (Uccle, Belgium)* (Cat. 10). He appears to have omitted evidence of the war in much of his work, but there were a few significant exceptions. One of the best known is his amazing *Requisition of Horses, Uccle Town Square* (Cat. 25), which depicts the German procurement of the animals so necessary for the town's livelihood. Raphael made this work vivid through the circular profusion of the gathered horses, the consternation of the anonymous villagers, and the confinement of the scene within the town square bordered on three sides by solid geometric structures. More powerful reflections of the wartime situation can be found in a pair of wash drawings of about the same year, *Russian Prisoners* (ca. 1915; location unknown) and *Bread Line* (ca. 1915; location unknown), where the dark tones reinforce the huddled compactness, creating unrelieved tension and despair in the confined but seemingly endless mass of humanity.

But what may be Raphael's most significant reaction to the war is his startlingly expressive *The Milk Line* (Fig. 9). Here masses of women and children on a sidewalk pour into the street, merging into one block of tortured humanity, the men with milk

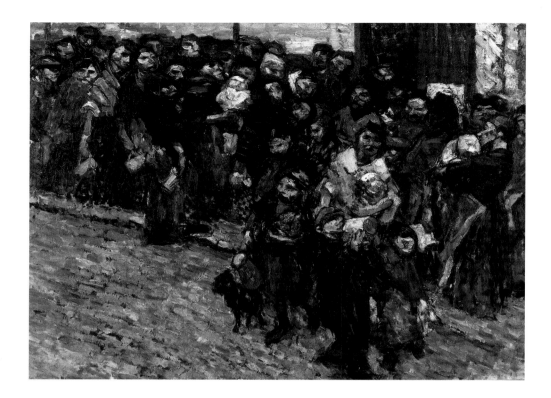

pails, the women often accompanied by their children. The overall blockiness of these slowing surging forms contrasts with the empty street on the lower left. The touches of bright colors—white, yellows, vermilions, blues, and purples—lend an even greater air of hopelessness to the dark, diverse groups. Raphael, whose own situation is almost surely reflected in their plight, was one of the few American artists who was forced to exist under enemy occupation, and there is an intensity here in the despair of mankind unlike, for instance, George Bellows's horrific scenes of Belgian occupation, created at a safe distance in the United States, or Marsden Hartley's fairly decorative militaristic abstractions painted in Berlin. Though his art is usually far from the singular aesthetic of his Belgian contemporary James Ensor, who painted in Ostend, here Raphael shares the great artist's sense of psychologically tortured, undifferentiated humanity.[42]

Despite, or perhaps because of the War, Raphael's artistic strategies began to change about the middle of the decade. His new approach may have been less appealing to his constituency, regardless of what seems to have been his considerable success with his San Francisco patronage. We may never know why Raphael changed his manner. Perhaps it had something to do with the war and with the greater difficulties that the artist encountered in seeking out Dutch fields as subjects. Even more likely, Raphael may have felt that he had carried Impressionist and Post-Impressionist aesthetics as far as he could—or cared—to take them; these strategies were no longer in the forefront as modernism spread. Raphael may simply have felt the need for change. In the period that followed he concentrated

increasingly on local subject matter—his family and his immediate surroundings—and adopted a more powerful approach. He took on several such approaches in which, often without downplaying his love of color, he created greater pictorial density and used more vivid brushwork in pursuit of a vitality of forms, both visceral and structural.

Rhododendron Fields (Belgium) (Cat. 4) is a transitional work that leads toward Raphael's new direction. The color range, though light, is limited, and while recession is not negated, the brushwork is equally active throughout the flowery field, with the paint laid down in broad, flat strokes rather than dots or splotches. The rhododendron garden could have been painted in any flowering field, but it was probably executed at or near the artist's home. Raphael's new expressive use of paint is also seen in *Tea in the Orchard* (Fig. 10), which, in spite of the vigorous painterly technique that defines the figures, shows the artist's children sitting around a table in an engaging and intimate family scene. Years later, when this painting was included in Raphael's one-artist show at the Oakland Art Gallery in January 1933, one critic wrote: "Here the artist has given his imagination full play with sunlight falling through flowering trees. It is an example of true impressionism carried to its farthest point to be safe."[43]

Even more typical of this period in Raphael's art is *The Japanese Doll* (1916; private collection), a close-up of the artist's children seen among a mass of flowers and toys, with slabs of paint creating both figural structure and the overall composition.

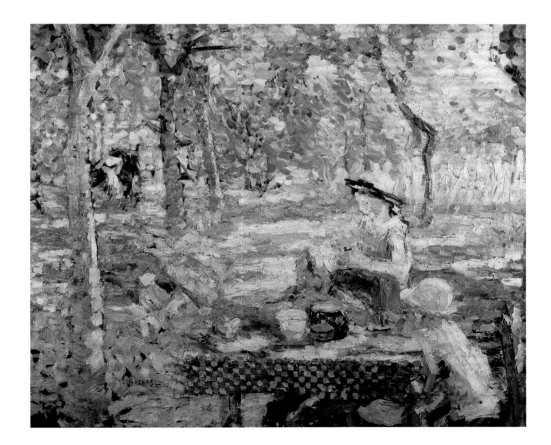

Fig. 10.
Tea in the Orchard,
ca. 1916, oil on canvas,
39 × 46¾ in., Garzoli
Gallery, San Rafael,
California.

Perhaps even more characteristic of Raphael's new direction is *In the Orchard, Belgium* (Cat. 32), in which the color is heightened tremendously, with an emphasis on bright yellows, reflecting intense sunlight. While the artist concentrated on the activities of his children around a table, the foliage in the background resists any recession and the garden chair in the lower left firmly establishes the frontal plane. Many of these more expressive paintings incorporate the artist's family, but Raphael also used many of the same strategies in his *Bowling (Boule)* (Fig. 11), in which contrasting streaks of color indicate the bowling path and the overhanging foliage while also offering a rare glimpse into the simple pleasures of country life.

Raphael's *Neighbors (Belgium)* (Cat. 29), again involves his newer, more expressive use of paint. Instead of dots or blotches, he employed long, expressive brushstrokes to suggest the parallel movement of the young people, perhaps on their way to school. Raphael's tendency to view humanity as an integrated composite rather than specific individuals, which emerged especially in his World War I pictures, continued in such works as *Fish Buyers (Fish Market, Brussels)* (Cat. 28), with its almost claustrophobic massing of a semicircle of virtually undifferentiated figures, a haunting embodiment of contemporary peasant life. This ever-more Expressionist approach received critical comment back in San Francisco when Raphael's work was shown at the Helgesen Gallery in 1920. Winchell noted in the *San Francisco Chronicle*: "The artist paints in the broadest possible manner, sweeping on paint with lavish strokes, merely indicating details. The subjects must be viewed from afar distance to gain their meaning and texture. If the method is not easily comprehended at least no one will fail to be compensated by the beauty of light and color."[44]

Fig. 11.
Bowling (Boule), ca. 1918, oil on canvas mounted on board, 64 × 60 in., Oscar and Trudy Lemer Collection

The New Blue Door (Belgium) (Cat. 40) may be Raphael's masterpiece at this stage in his career. Broad strokes of contrasting tones—yellows, oranges, blues, and greens—define the ground plane and the foliage at the left. But the composition concentrates on the artist's home; its whitewashed wall acts as a foil for the intense blue of the newly painted door, while complementary orange and orange-brown define the sloping roof above. The sense of color structure here is supreme and would suggest the impact of Raphael's study of the work of Cézanne, whose influence can be found in a variety of Raphael's paintings from this time.

Of the works of Belgian artists active then, Raphael's paintings bear comparison in a number of cases with some of the earlier paintings of Jean Brusselmans, who, like Raphael applied blocky brushwork to figures out of doors. Brusselmans also lived for a while in Uccle.

It appears, however, that while Raphael was vigorously applying paint and intense coloration to some of his pictures of his family in the late 1910s, he was also utilizing a much more subdued palette and sometimes a quieter handling of pigment in his landscapes (Cat. 24), especially in some featuring reflections in water. These are, of course, less personal, more traditional subjects, such as his *Fields near St. Job (Uccle, Belgium)* (Cat. 10), in which he built up his forms by alternating long brush-strokes of blues and greens and contrasting pale russet and orange. In his *Pond in Linkebeek, Early Autumn* (ca. 1916; private collection), the reflections in the water are sufficiently intense that the brushwork of the near shore and the distant house and foliage across the pond are almost united by the painterly activity across the entire surface of the work, despite the obvious spatial recession. Contrasting tones are stronger in *At Mr. Wiggins's (Uccle, Belgium)* (Cat. 22), which, like his *Bowling (Boule)*, testifies to the simple pleasures of country life. The same is true of his *Fishing in the Garden of Papekasteel (Belgium)* (Cat. 19), which again features a limited palette of blues and oranges. Probably the most lovely of this series is his *The Old Mill Pond (Belgium)* (Cat. 23), where the glistening blue of the water occupies the lower half of the painting, itself reflecting the row of green trees and small houses on the far bank. This is an idyllic scene, but it is handled with subtle but strong brushwork, especially in the varied greens of the trees, while the reflections in the water are Cézannesque.

Still Lifes and Graphic Work

Raphael's art appears most indebted to Cézanne in the still-life paintings he created about 1921. Whether he turned to this subject matter because of weather too inclement to allow for outdoor work or because he wished to tackle a new genre cannot be determined; the cause for this investigation may lie in a combination of explanations. Indeed, *Apples* (Fig. 12) is one of the finest paintings Raphael ever produced and perhaps the finest still life produced by any California artist in the twentieth century. Raphael has completely understood Cézanne's method of creating volume by planes of color. He subtly modeled each piece of fruit with variations from yellow-orange to orange to vermilion. He contrasted these vivid tones with the dull blue-grays of the ginger jar matched by the wall coloring. With the same intensity, the slightly purple-gray tabletop is tipped forward to place the fruit both on the surface of the picture plane and in space. The apples themselves are disported on the table in a fascinating pattern; as they gather closer to the white

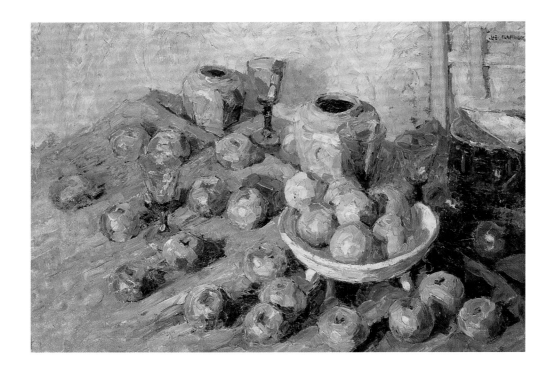

dish that holds about eight of them, they form an accumulation of brightly colored, well-structured fruit.

While no other still life by Raphael commands quite such mastery, this is not an isolated achievement. His *The Christmas Table (Apples and Goblets)* (Cat. 42) is another expert work, although more decorative, with its patterned dishes, beautifully rendered glassware, and the white tablecloth used as a screen for the colorful fruit and blue glassware. *Still Life* (ca. 1921; Mills College Art Museum) is more diverse, with pears rather than apples, a wine bottle enclosed with straw, and a potted plant; however, the range of still-life elements somewhat lessens the intensity of his apple pictures. Raphael's *Still Life with Corn Husks and Cabbage* (Cat. 46) is an especially strong work, truly a kitchen painting in the mode that goes back to the still-life painting of Jean-Baptiste Siméon Chardin in eighteenth-century France. Indeed, vegetables are a subtheme of still life, best captured in this country in some of the works of William Merritt Chase. Raphael also painted flower still lifes, such as his *Still Life with Red Poppies* (Cat. 41), in which he contrasted the rich coloration of the flowers with the white container; here he was less concerned with Cézannesque structure than in his fruit pictures.[45]

Raphael had remained in contact with some colleagues and schoolmates from his San Francisco days; he often asked Bender about Anne Bremer, and wrote to him that Gottardo Piazzoni had visited for several days in mid-September of 1921.[46] Raphael's support from the art community of San Francisco, though not from Albert Bender, may have begun to wane about this time. On September 21, 1921, he noted that Helgesen was changing location and suggested the return of unsold work;

nonetheless, he continued his association with the gallery. The next year he noted to Bender that he had not done much painting for the previous three or four years.

Instead, Raphael appears to have concentrated on printmaking during the following decade. He had been involved in the graphic arts since 1912. In that year he was included in two group shows of the California Society of Etchers, and in the next year he sent a group of etchings to an exhibition at Helgesen's. He continued to produce etchings at least through 1922 and continued to show them at Helgesen's. However, inspired by his admiration for Japanese wood block prints—especially those of Hokusai and Utamaro—he turned to woodcuts for the first time in 1923 or 1924. The medium of woodcut had been revived in the late nineteenth century, partly inspired by Japanese examples, and interpreted in a modern mode by artists such as Paul Gauguin and others. Interest in the medium continued in the early twentieth century, especially by German artists of the Die Brücke movement and by Americans such as Max Weber, although the revival was really international. Raphael chose this medium both for pleasure and convenience; he enjoyed the process of making woodcuts and, as they alleviated the necessity of transporting etching plates either to The Hague or to Brussels for printing, he relished the directness with which they could be produced. Raphael exhibited his prints in San Francisco and sold some of them to the Royal Print Cabinet of Amsterdam. He also showed them at the gallery of Dietrich & Co. in Brussels, though information on those exhibitions is scant.[47]

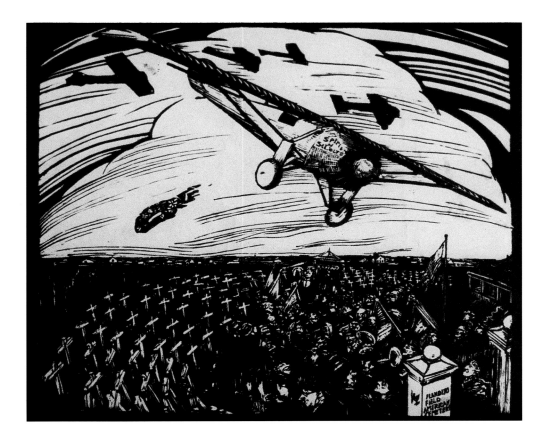

Fig. 13.
Lindberg Flying over the American Soldiers' Graves at Flanders Field, American Cemetary, Wareghem, Belgium, 1927, woodcut on paper, 17⅜ × 19⅛ in., courtesy Johanna Raphael Sibbett.

Raphael's woodcuts are striking indeed, with vivid areas of black often silhouetted against the white of the paper, with little or no background. They range from simple landscapes depicting areas in the vicinity of the artist's home, such as *Summer* (ca. 1927; private collection) or *Railroad Tracks near Artist's Home* (1928; private collection), to dramatic views, such as an image of an airplane over Flanders Field in *Lindberg Flying over the American Soldiers' Graves at Flanders Field, American Cemetery, Wareghem, Belgium* (Fig. 13). Raphael also devoted his graphic skills to depictions of his own family (Cat. 68), which included Catherine; the couple's first-born and only son, Pieter Nicholaas Raphael (born January 18, 1912); and their daughters, Elizabeth ("Liesbeth," born April 22, 1914), Marie-Jeanne ("Dany" or "Danny," born March 3, 1918), and their last child, Johanna Irène ("Joke," born August, 25, 1919). Raphael's most striking woodcuts of the later 1920s include *Artist's Daughter Liesbeth at the Piano* (1925; estate of the artist); *Duo for Violin and Piano* (1926; estate of the artist), which depicts Catherine and Elizabeth playing together; and the stong image, *Catherine before the Jury* (1929; estate of the artist).

Return to Holland

By the late 1920s, a return to Holland was beginning to appeal to the Raphael family. In August of 1928, they enjoyed a vacation in Leiden, in part to visit the collection of Japanese prints there in the National Museum of Ethnology, one of the finest of such collections in the country. The following year, the family left Belgium and moved to Oegstgeest, a suburb of Leiden, which offered better schools and medical care and ended his wife's homesickness. During the Depression years, however, sales of Raphael's art frequently fell drastically, and he often traded works for food and services. He concentrated primarily on watercolors and woodcuts. By the mid-1930s, inspired by the Japanese prints he admired, he occasionally added color to the latter. At the same time, Raphael continued to offer his work for sale in San Francisco. In January 1929, in what may have been his first one-artist show since 1920, when his art was featured at Helgesen's, an exhibition of his work was held at the Valdespino Gallery at 345 O'Farrell Street. H. Valdespino had been Raphael's principal agent at Helgesen's, which seems to have reduced its operation in the early 1920s. This 1929 exhibition of Raphael's work brought the artist renewed attention and acclaim, and Raphael remained with Valdespino until 1934.[48] In addition, Raphael's paintings regularly appeared in the annual exhibitions of the San Francisco Art Association and at other venues on the West Coast.

Once back in Holland, Raphael became more attuned to the artistic community. However, according to his family's recollections, he did not frequently socialize with artist friends,[49] and he was associated only with the local, amateur artist com-

munity. He found models, for instance, through Ars Aemula Naturae, a Leiden organization of nonprofessional artists with which he had been connected since 1933. He contributed to their exhibitions until he left Holland six years later. Raphael also had several one-man shows in Holland. On May 3, 1933, he reported from Oegstgeest to Bender that he had a show of his work in nearby Leiden, an obviously extensive exhibition, consisting of ninety woodcuts, forty watercolors, and fifteen or twenty oils of Bruges as well as a few portraits of children. The show, originally meant to last two weeks, was extended for a month. He reported to Bender that the oils received little consideration but that the woodcuts were a success. This was followed by a show in The Hague at Bas Van Pell, an obscure shop with a practically unknown dealer, which he deemed an artistic but not a financial success.[50] Raphael was hoping to have another exhibition in Leiden in 1934; in December of 1935, he had an exhibition there of woodcuts, watercolors, and several dozen oils in a local art store or shop, "De Ploeg," [The Plow] on Breestraat.[51]

Raphael and his family had never traveled greatly, surely due in part to financial exigencies but also perhaps because he felt no need to do so, satisfied with the subjects he painted in and about his various homes. Indeed, the piano and violin lessons taught respectively by his wife and Catherine became the family's chief means of support. However, his wife's illness from pneumonia and pleurisy compelled them to travel moderately, and they spent May and June of 1929 in Menton on the French Riviera, at the advice of their physician, Dr. Georges Marlow, shortly before their move to Oegstgeest. Marlow, like the family dentist, Walter Fay, were paid in works of art.[52]

Watercolor may always have been an alternative medium for Raphael, but it was ideal for work done on his travels, given its limited demands for materials and portability. In October 1929, Raphael sent forty-three watercolors to San Francisco. There a fire at Valdespino's Gallery in January of 1930 destroyed much of his work, but it did provide him with a substantial insurance payment. Still, his Dutch reputation now rested primarily on his woodcuts, and on December 26, 1931, he received a rare but glowing review of his work by the critic Otto van Tussenbroek in the Dutch weekly, *De Groene Amsterdammer*: "Whoever takes in hand a print from a wood block of Joe Raphael and examines it carefully must acknowledge this to be one of those rare talents who in simple opposition of black and white can give more than simple black and white; again and again it seems as if color is suggested in what is really colorless. His work sparkles with life, his vision of the things he engraves is notably original and exceedingly personal, while the unusual composition always fascinates. Pervading all these subjects is a great secret of life that resounds through all true expressions of art."[53] Van Tussenbroek became one of Raphael's chief critical supporters, publishing a second article on the artist's woodcuts that appeared in

Op de Hoogte in May of 1933 along with nine illustrations of the artist's work.[54] With this heightened, if still local, interest, especially in his woodcuts, Raphael responded in July 1933 to the request of Dutch critic Albert Plasschaert for a short autobiographical statement, with one that emphasized his graphic art.[55]

Throughout the 1930s, Raphael also continued exhibiting at the San Francisco Art Association, and in early January 1933 the Oakland Art Gallery held an exhibition entitled, *Paintings by Joseph Raphael: One of America's Greatest Impressionists.*[56] The show was mounted in three galleries—one for oils and temperas, one for watercolors, and one for woodcuts and etchings.

After mostly having abandoned painting for a number of years, Raphael began to work in oils again in 1932. That summer and fall, he spent several months in Bruges. There, for the most part, he avoided the famous buildings, the Gothic churches and other edifices that were part of the tourist attractions of the city. However, he did paint the *Béguinage, Bruges* (1932; private collection), a historic structure founded in 1245 by the Countess of Flanders (though most of the buildings of the Béguinage were constructed in late Baroque style).[57] For the most part, he enjoyed the quiet beauty of the canals, the reflections of the stone bridges crossing them, and the overhanging foliage, which he painted in the quietly expressive brushwork and subdued palette seen in *Pont de Cheval, Bruges* (Cat. 50) and *Canal and Bridge, Autumn (Bruges)* (Cat. 51). In contrast with these more idyllic canal scenes is Raphael's *Groene Rei, Brugge* (Cat. 53), a very vigorously executed scene, in which the neutral tones of bridge and building walls are vividly offset by the green foliage and the vermillion roofs. There is a real tour-de-force here, with Cézannesque strategies especially evident in the contrast between the spatial diminution of the receding row of peak-roofed buildings and the insistent intensity of their color.

To Italy and San Francisco

Mrs. Raphael's illness took her to the Mediterranean again in 1933, where she was joined by her husband in July. They remained in Santa Marguerita on the Portofino Peninsula. One result of Raphael's activities there was a January 1935 exhibition at the Gelbert-Lilienthal Gallery in San Francisco of his Mediterranean watercolors, especially those painted around Menton. Generally, Raphael's watercolors received far less attention than either his oils or prints, especially the woodcuts, but these works were praised with great enthusiasm for the retention of sunshine, open air, and atmospheric color. Perhaps not surprisingly, the "dynamic draughtsmanship of van Gogh" was also introduced as an influence.[58] In the summer of 1938, Raphael and his wife vacationed in Cannero on Lago Maggiore, Italy, where they hoped to

retire. A number of views of Cannero by Raphael are known, painted before they returned to Holland by way of Lake Como and Venice.

The following February, Raphael left his family and boarded a boat from Rotterdam to New York. He then traveled by bus to San Francisco, where he rented a small studio apartment before moving to a small room in the one-story Hotel Wall at the corner of Bush and Franklin Streets, above Hermann's Market (owned by his brother-in-law, Joe Hermann). It was here that Raphael lived for almost the remainder of his life.[59]

Many factors contributed to Raphael's decision to stay. He continued to be demoralized, both financially and emotionally, by the Depression and was eager to see his family and friends in California. Of more immediate importance, however, was the threat of Nazism, and the imminent peril that Raphael, as a Jew, felt in the wake of the treatment of the Jewish residents of Germany. As early as November 29, 1933, he had written to Bender: "the uncomfortable neighbor on the Rhine is making things very uncomfortable for the world, particularly for the Jews. He has only begun; where will it finish?"[60] A little over a year after Raphael's departure from Holland, the Germans invaded Holland.

Raphael's return to San Francisco must have engendered both tremendous confusion as well as a sense of psychological displacement. On the one hand, he was safe from the impending international catastrophe, but on the other, he was separated from his wife and children. Marie-Jeanne joined him in May, and later in the decade his other daughters also appeared, but he was aware of the increasing oppression of family members who remained in Holland. Most tragically, his wife died of a heart attack in Oegstgeest on December 3, 1945, shortly after the war ended. In the final year of the war, fuel as well as food was scarce. After burning the wood furniture, his family had to cut and saw up the cherry and pear wood blocks, preserved in the attic crawlspace in Oegstgeest, that Raphael had used for about two hundred of his woodcuts.[61]

In California, Raphael had old friends, companions, and patrons with whom to share his time; indeed, a special welcome organized by Bender for him on May 5, 1939, at the San Francisco Art Institute, where ten of his paintings were on view.[62] But many of his fellow artists from his days at the Mark Hopkins Institute had passed away, and on March 4, 1941 Bender died.

As an artist, the successive stages of Raphael's painting development had little relevance to the Bay Area in 1940, where the Bay Area Fauvism of the Society of Six, prominent in the 1920s, was followed by the Social Realism of the Depression era. This was then displaced in the mid-1940s by the abstractions of Clyfford Still, Edward Corbett, and, by the end of the decade, Richard Diebenkorn. In the increasingly copious writing on the art of the Bay Area, the late 1930s and 1940s are singu-

larly unfocused. Raphael's return, therefore, should have introduced a vital infusion of pictorial creativity, especially considering the works he was to paint soon after his arrival, but there appears to be no record of such an impact. On February 15, 1943, Clapp wrote to Selden Gile, his former comrade in the Society of Six: "I suppose you know that Jose [*sic*] Raphael has been back in San Francisco for the last three or four years and has served on the juries of selection here a couple of times. I don't think that he is doing a great deal of painting these days—possibly because of discouragement at the change in art fashion that has made Impressionism less popular with artists than it used to be."[63]

Immediately after his return to San Francisco, Raphael produced a series of beautiful paintings of the Japanese Tea Garden, an idyllic oasis located in Golden Gate Park (Cats. 54–59). Many of these bear variations on the title *Japanese Tea Garden*. These pictures of the lanterns, bridges, and pavilions in one of the city's most beautiful and best-known garden attractions are among Raphael's loveliest works. In their vivid pictorial handling and chromatic and tonal contrasts, they indicate no lessening of his creative abilities. Raphael's *Japanese Tea Garden with Lantern, Golden Gate Park, San Francisco* (Cat. 54), for instance, offers a marvel of modernist strategies, with the yellow and orange structure of the openwork teahouse itself, immersed in the foliage of the garden and perhaps the wisteria that often created a partial veil for its roof, offering a contrast to the large, solid blue lantern in the lower right. Here, Raphael has revived the brilliant coloration of his Impressionist canvases of two and a half decades earlier, while applying his pigments with the expressive brushwork that he had developed simultaneously.

Beyond their sheer attractiveness and appeal to tourists, one can only speculate as to what drew Raphael to this motif. Perhaps in a city that had witnessed such great changes, the Tea Garden remained for Raphael a place of fond memories, for it was first developed as the Japanese Village at the 1894 *California Mid-winter International Exposition* or *World's Fair*, a highlight of Raphael's early student years and associated with his first exposure to art. At the same time, the Tea Garden provided him with a refuge from the changes that must have been dizzily startling after so many years away from home.

From the number, size, and importance of this series of paintings, one would expect the Japanese Tea Garden paintings to have been featured in an exhibition devoted solely to them, but there is no evidence that this ever occurred. A show of Raphael's paintings and prints held at the San Francisco Museum of Art from December 15 to 31, 1939, was briefly mentioned in the *San Francisco Chronicle*, but the exhibition's contents appear elusive. The short commentary in the *Chronicle* is devoted mostly to the woodcuts and suggests that the paintings shown were earlier works rather than the Japanese Tea Garden series.[64] Another review praised his oils

that "use such a rugged brush stroke in their dazzling mixture of colors that they often assume almost the quality of mosaics," a comment certainly applicable to the Japanese tea garden paintings.[65] Unfortunately, no listing of the works in the show has been found. While some of Raphael's Tea Japanese Garden pictures are gently bucolic, the artist was obviously fascinated by the garden's exotic architecture. In *Pagodas in the Japanese Tea Garden, Golden Gate Park* (Cat. 59), the artist assumed a low viewpoint, looking up to the multitiered pagoda at the left, juxtaposed with the Temple Gate in the center, which had been part of the Japanese presence at the 1915 Panama-Pacific International Exposition and subsequently moved to the garden. The two structures are framed against a rich, purple sky, contrasting with the Impressionistically rendered light-colored foliage in the foreground.

Raphael had returned to San Francisco just weeks after the opening of the *Golden Gate International Exposition*, held at Treasure Island in San Francisco Bay. This was perhaps the last of the old-style world's fairs, which at the same time was meant to provide employment during the Depression period. The fair actually took place in two separate seasons, closing on September 19, 1940, with a six month "sabbatical" in the middle. Raphael was represented in two sections in the 1940 *Official Art Catalogue of the Golden Gate International Exposition*. In the section "California Art in Retrospect—1850–1915," the Oakland Art Gallery was listed as the lender of his *Flanders Field* (ca. 1927; location unknown), while one of his Japanese Garden paintings appeared in the section on "California Art Today."[66] Alfred Frankenstein commented on the former painting, allying Raphael with Clapp and Armin Hansen, as among the representatives of the Impressionist movement, but made no comment on the Japanese Tea Garden painting.[67]

In April of 1941 the Helgesen Gallery, with which had Raphael remained connected, held the artist's final lifetime one-artist exhibition, including over one hundred of his paintings, watercolors, and prints.[68] That October Gump's department store in San Francisco showed a group of Raphael's woodcuts; they continued to show his woodcuts through the decade.[69] He was also a fairly regular exhibitor at Clapp's Oakland Art Gallery, and in September of 1941 his *The Japanese Doll* (1916; private collection) was included in the *National Exhibition of Sculpture and California Painting*, held by the Los Angeles County Fair Association in Pomona. This painting had been a purchase prize at the Los Angeles Museum of History, Science, and Art (now the Los Angeles County Museum of Art) in 1924; it was loaned out by the museum for long periods until it was sold in 1978.

Most of the works of Raphael's final eleven years are watercolors and woodcuts. Perhaps the death of Bender in 1941 led Raphael to abandon painting full-time for about three or four years, from 1942–43 until the spring of 1946. During this interval, he worked first in a machine shop and then took a position cleaning optical

equipment for the navy at the California Academy of Sciences. However, from about 1942 until 1944, Raphael took lunch breaks to paint large gouaches of marine animals and fish at the Steinhart Aquarium, in Golden Gate Park (after the devastation of the earthquake of 1906, this structure was rebuilt in 1923; it was not far from the Japanese Tea Garden). These include *Salamander* (ca. 1944; estate of the artist), *Frogs, One Playing a Bass Fiddle* (1944; private collection), and *Turtles and Fish in the Aquarium, Golden Gate Park* (Cat. 62). The sense of constant motion, the striking palette, and especially the spatial disjuncture make these paintings among the most modern examples of Raphael's art, though it was not a direction he intended to follow.

During the 1940s, Raphael mostly concentrated on watercolors and woodcuts of the city and the surrounding area (Cats. 60–61). Some depicted sites that may have been familiar to him in his youth, such as the watercolors *Seal Rocks* (ca. 1941; Achenbach Foundation of Graphic Arts, San Francisco) and *Fisherman's Wharf* (ca. 1942; private collection). Raphael was also becoming very up to date on the city's cultural development. Pierre Monteux had just taken over as principal conductor of the San Francisco Symphony in 1936 and Rosalie Meyer Stern had instituted the Stern Grove Festival Association in 1938. Raphael was impressed by Pierre Monteux's conducting in Stern Grove, a panorama of culture within a natural setting, and he wittily rendered this subject using colored blocks to add chromatic interest (Cat. 70). Thus Raphael's prints commemorated the city's musical advancement.

Raphael was especially impressed, almost like a tourist, with what for him must have seemed a newly enlarged metropolis. His colored woodcut *Corsages, Grant Avenue, San Francisco* (Cat. 72) plays down the exotic distinction of the area in favor of an elongated stretch of roadway bordered by a multiplicity of buildings, while the viewpoint of his *California and Stockton (San Francisco)* (Cat. 73), seen from on high, depicts a pagoda-shaped building surrounded by a ring of tall skyscrapers, a relatively rare example of a California painter reveling in such tall, modern structures.

In the background of *California and Stockton (San Francisco)* one of the spanning arches of the San Francisco-Oakland Bay Bridge can be seen. This bridge had opened late in 1936; the Golden Gate Bridge was completed in the following summer. Raphael found these structures, especially the latter—the western entranceway to America—endlessly fascinating. They must have seemed incredible achievements to the artist, who had been mostly surrounded for the past thirty-five years by traditional village life. In his images he celebrates the new technology that had brought together the separate stretches of land at the Golden Gate a marvel that was shared by the entire citizenry that he had rejoined. The Golden Gate Bridge is viewed close up in his *Golden Gate Bridge* (ca. 1947; private collection), while it is seen from afar in both *Lands End, Golden Gate Bridge* (ca. 1947; private collection) and *Roofgarden*

(ca. 1941; estate of the artist). In the first of these, Raphael concentrated on the structural mass of the bridge, contrasting it with the small ships sailing below. In the latter two, the bridge literally replaces the horizon, the manmade structure sealing up both the swirling water and the homes nestled on the near hillside.

In 1950 Raphael moved out of his hotel room into an apartment; there his family and in-laws joined him for meals. He was now able to enjoy comparative comfort. Over eighty years old, the artist was to make one more excursion into new territory and expanded aesthetics when he made his first visit to Yosemite Valley in April of 1950. He returned soon after for a six-month stay at Camp Curry, producing a body of beautiful, spiritual paintings that continue the tradition of glorifying what had long been known as the "American Eden." These include several close-up watercolor views of waterfalls, *Vernal Falls* (ca. 1950; private collection) and *Yosemite Falls* (ca. 1950; private collection). *Yosemite Falls*, with its contrast of bare areas of white and dense, sometimes jagged foliage below, is among the most Asian-influenced of all his pictorial conceptions. Raphael also painted more panoramic views of the great Half Dome cliff, as in *Half-Dome, Yosemite* (Cat. 64). A colorful example includes a grove of tall trees and visitors patronizing the lodge below while the mountain towers in the background (Cat. 63). *Half-Dome, Yosemite* is not playful at all, but rather captures the ruggedness of the mountains with a limited palette and strong tonal contrasts that recall Raphael at the height of his career in the mid-1910s. Paint is used to glorify the grandeur of Yosemite as well as to offer verification of the artist's continued mastery at the end of his career. Shortly after this trip, Raphael died in Maimonides Hospital in San Francisco on December 11, 1950.

Although resident abroad for many years and never fully integrated into the artistic life of the community from which he had emerged—and to which he had remained devoted during his lifetime—Raphael, nonetheless, had established himself as one of San Francisco's greatest and most innovative and unique artists in a variety of mediums for the first half of the twentieth century.

This essay is dedicated to Harry Koenigsberg, a great lover of art, and especially of American art. He was also my great friend, and I am tremendously proud of our long friendship.

1. *Joseph Raphael 1869–1950*, exh. cat. (Laren, Holland: Singer Museum, 1981), remains the best-known catalogue and exhibition devoted to Raphael's work. In 1980, the Stanford University Museum of Art held a magnificent show, *Joseph Raphael: Impressionist Paintings and Drawings*, but unfortunately no catalogue was ever published. Anita Ventura Mozley, the curator, kindly furnished me with the checklist, chronology, and the typescript of the unpublished catalogue's text, hereafter referred to as Mozley,

"Raphael." See also Gene Hailey, ed., "Joseph Raphael," in *California Art Research* (San Francisco, Calif.: Works Progress Administration, 1936–37), vol. 5, pp. 32–42; Raymond L. Wilson, "Joseph Raphael," in *Plein Air Painters of California. The North*, ed. Ruth Lilly Westphal (Irvine, Calif.: Westphal Publishing), pp. 160–66. The San Francisco Museum of Modern Art held a memorial exhibition of Raphael's work in January 1951, and in January–February 1960, a show of Raphael's paintings entitled *An Exhibition of Discovery: Joseph Raphael, 1872 [sic]–1950* took place at the California Historical Society.

2. In the summer of 2002, the Monterey Museum of Fine Arts held an exhibition, *Joseph Raphael—American Expatriate: Impressionist Paintings from the Collection of Oscar and Trudy Lemer*. The accompanying catalogue includes a short, perceptive essay by Mary Murray.

3. I wish to offer tremendous appreciation to Paula B. Freedman, who thoroughly searched the public and archival sources of the Bay Area for material on Raphael and brought to light a great deal of information without which this essay could not have been written. Her compilation of material from the Oakland Museum of California Art Archives has been especially valuable.

4. Bender would ultimately bequeath about twenty-five of Raphael's paintings and etchings to the Mills College Art Gallery, Oakland.

5. Much of the biographical information on Raphael is derived from an autobiographical letter of July 1933 requested of him by the Dutch art critic Albert Plasschaert. Raphael Catalogue Raisonné Archives. Raphael's place of birth has sometimes been given as Amador City in the Sierra Nevada foothills, but this is inaccurate; his association with Amador City occurred during his youth as a gold washer for a mining company there.

6. On the history of the San Francisco Art Institute, see Kate Montague Hall, "The Mark Hopkins Institute of Art," *Overland Monthly* 30 (December 1897); pp. 539–48; "Art and Education in San Francisco," *Harper's Weekly* 46 (June 28, 1902), pp. 820–21; Kent L. Seavey, "The Foundation and Early Years of the San Francisco Art Association and the California School of Design," in *Artist-Teachers and Pupils, San Francisco Art Association and California School of Design: The First Fifty Years, 1871–1921* (San Francisco: California Historical Society, 1971); Harry Mulford, "History of the San Francisco Art Institute," *San Francisco Institute Alumni Newsletter* (May 1978), p. 2; (August 1978), p. 2; (November 1978), p. 2; (February 1979), pp. 2, 5; (May 1979), p. 2; (August 1979), p. 2; (Spring 1980), p. 2; Raymond L. Wilson, "The First Art School in the West: The San Francisco Art Association's California School of Design, *American Art Journal* 14 (Winter 1982), pp. 42–55; and Westphal, *Plein Air Painters of California*, p. 17.

7. The Mentons also acquired works by artists such as her teacher, Alfred Mathews and the still-life specialist William Hubaceck. Many of Menton's paintings were destroyed in the earthquake and fire of 1906; she is best known today for her later paintings of California missions.

8. "Notes from the Studios," *San Francisco Chronicle*, December 16, 1900, p. 12. My gratitude is extended to Alfred H. Harrison, Jr., of the North Point Gallery, San Francisco, for this and many of the other clippings from San Francisco publications used in this essay.

9. For her investigation of notices of Raphael in Laren, my tremendous thanks are due to my friend and colleague, Annette Stott, the primary authority on American artists in The Netherlands.

10. Letters from Albert Krehbiel to Dulah Evans, 1904–06. Researched by Margot Bowen and Jane Meyer, these are courtesy of the Krehbiel Corporation, Evanston, Illinois.

11. Laura Knight, *Oil Paint and Grease Paint* (New York: MacMillan Company, 1936), p. 141.

12. The most thorough examination of Krehbiel is *Krehbiel: Life and Works of an American Artist* (Washington, D.C.: Regnery Gateway, 1991), with an introduction by Robert Guian. Raphael is not mentioned in the text of this volume.

13. See Neuhuys's *Woman of Laren with a Cradle* (Singer Museum, Laren, Holland), reproduced in Jan P. Koenraads, *Laren en zijn schilders Kunstnaars rond Hamdorff* (Laren, Holland: Judi Kluvers, 1985), p. 17. The artists of the foreign colony there are not included in this study.

14. Knight, *Oil Paint and Grease Paint*, pp. 156–57.

15. *La Fête du Bourgmestre* was praised and was the first painting illustrated in Paul Jamot, "Les Salons de 1906," *Gazette des Beaux Arts* 35 (3rd period, 1906).

16. Joseph Raphael to Albert Bender, 1911, quoted in Mozley, "Raphael," p. 11.

17. "There will be rejoicing that 'The Town Crier' by Joseph Raphael, purchased recently by Raphael Weill for the art gallery of the Memorial Museum in Golden Gate Park, was saved. It had been in the spring exhibition in the Mark Hopkins Institute of Art." "Paintings and Statuary saved from Hopkins

Institute," *San Francisco Chronicle*, May 13, 1906, section 3, p. 1, courtesy of Oscar Lemer. My gratitude to Alfred H. Harrison, Jr., for this article.

18. Laura Bride Powers, "Joseph Raphael's Great Picture," *San Francisco Call*, January 7, 1906, p. 23. Courtesy of Alfred H. Harrison, Jr.

19. Paul Jamot, "Les Salons de 1906," *Gazette des Beaux Arts* 35 (1906), pp. 492–93. As translated into English, Jamot's commentary was: "The large painting of Mr. Joseph Raphael is one of the most pleasant surprises of this year's Salon…there is perhaps a reference conscious or subconsious to *The Night Watch*; but more importantly there are exceptional qualities of a fine painter, which indicate greater things to come; with a keen observation of those common Flemish types, with jovial and rubicund faces, recorded with ease, and in doing so aiding the composition with its balance of colored masses, love for strong colors, contrasting tones and rich paint, commanding a free touch and above all a youthful spirit and a love of painting, which delights us."

20. The "Bourgmestre" or "burgmeester" was the mayor. Actually, there was no Van den Broek who was major of Laren, though it is and was an old, established family in the town of Kortenhoef, near Laren. Pieter van den Broeck was not the mayor of Kortenhoef, but an alderman, the mayor and the aldermen making up the town's municipal council. Unfortunately van den Broek family members do not find a resemblance between Pieter van den Broeck and the principal figure in Raphael's painting. Information, courtesy of Dr. Carole Denninger-Schreuder of the Kunsthistorisch Service Bureau, Hilversum. I owe a tremendous debt to gratitude to Dr. Denninger-Schreuder, who advised with great perception on the state of Dutch and Belgian painting during Raphael's time and combed the contemporary Dutch magazines in search of references to Raphael and his art. My gratitude is also due to Agnes K. M. de Rijk of Laren for her research into the archives of the Singer Museum in Laren and other possible sources for information on Raphael's early years in Holland.

21. Knight, *Oil Paint and Grease Paint*, pp. 156–57.

22. The book was Jacob Baart de la Faille's *Vincent van Gogh* (Paris: Hyperion, 1939), but she recalls that her father's devotion to van Gogh's art had begun far earlier. Interview with Johanna Raphael Sibbett, September 16, 1996.

23. See *Jan Sluijters schilder met verve* (Zwolle, Holland: Waanders uitgevers, 1999; Laren, Holland: Singer Museum), pp. 33–35, 206. Sluijters's interaction with other early Dutch Modernists drawing upon van Gogh, such as Leo Gestel and, of course, Piet Mondrian, are beyond the scope of this study; although there is no documentary proof, presumably Raphael was acquainted with their work also.

24. Albert Bender's role in the development of the San Francisco art world has yet to be established. His gifts to the San Francisco Museum of Modern Art, founded in 1935, totalled 1,090. These were primarily by American, especially San Franciscan, artists. For more on Bender, see Oscar Lewis, *A. M. B.: Some Aspects of his Life and Times* (San Francisco, Calif.: Grabhorn Press, 1941); Jackson M. Dodge, "Patrons and Collectors: B. [*sic*] Albert Bender and the Early Years of the San Francisco Museum of Art," in Joseph Armstrong Baird, Jr., ed., *The Development of Modern Art in Northern California. Part II. From Exposition to Exposition: Progressive and Conservative Northern California Painting* (Sacramento, Calif.: Crocker Art Museum, 1981), pp. 41–44; Mary Street Alinder, *Ansel Adams: An Autobiography* (Boston: Little, Brown and Company, 1985), chap. 7: "Albert Bender," pp. 81–93.

25. On Anne Bremer, see Phyllis Ackerman, "A Woman Painter with a Man's Touch," *Arts and Decoration* 18 (April 1923), pp. 20, 73; Helen Dare et al., *Tributes to Anne Bremer* (San Francisco, Calif.: J. Nash, 1927); Gene Hailey, ed., "Anne Bremer," in *California Art Research* (San Francisco, Calif.: Works Progress Administration, 1936-37), vol. 7, pp. 88–128; Raymond L. Wilson, "Anne M. Bremer (1868–1923)," in *Plein Air Painters of California: The North*, ed. Westphal, pp. 38–41.

26. Bender appears to have maintained the insurance on Raphael's *La Fête du Bourgmestre* after it was donated to the San Francisco Art Association, along with other works in the Association's collection. A 1929 letter to Bender from the association recommended that the insurance valuation on the picture remain at $2,000, although noting that the painting was too large for the association to house, and that they had therefore lent it to the San Francisco Palace of the Legion of Honor. Letter of December 30, 1929, E. Charlton Fortune Scrapbook, Oakland Museum of California Art Archives.

27. Raphael, April 20, 1911, to Bender, Special Collections, Mills College Library, Oakland.

28. Raphael, July 12, 1911, to Bender, Special Collections, Mills College Library, Oakland.

29. The detailed reminiscences of Catherine Raphael and Johanna Raphael Sibbett, written in the

mid-1980s, contain a trove of material pertinent to the personal life of Raphael and his family, but have been sparingly used here in favor of concentrating on his artistic development and achievement. Raphael Catalogue Raisonné Archives.

30. Raphael, July 22, 1912, to Bender, Albert Bender Papers, Special Collections, Mills College Library, Oakland.

31. Raphael, January 1912, to Bender, Albert Bender Papers, Special Collections, Mills College Library, Oakland.

32. Raphael was the outstanding figure in *A Joint Exhibition of Five California Jewish Artists 1850–1928 In Honor of the 125th Anniversary of Congregational Emanu-El*, exh. cat. (Berkeley, Calif.: Judah L. Magnus Museum; San Francisco, Calif.: Temple Emanu-El Museum, 1975).

33. Dominique Colen and Denise Willemstein, *Ferndinand Hart Nibbrig 1866–1915* (Zwolle, Holland: Waanders Uitgivers; Laren, Holland: Singers Museum, 1996); summary in english, pp. 142–43.

34. Anna Cora Winchell, "Artists and Their Work," *San Francisco Chronicle*, April 2, 1916, p. 19.

35. Michael Williams, "News and Notes of the Art World," *San Francisco Examiner*, March 29, 1914, p. 32.

36. Everett C. Maxwell, "Art: Art Affairs in San Francisco," *Graphic* (March 1914), Los Angeles County Museum of Natural History Scrapbooks.

37. *Oakland Tribune*, April 15, 1916.

38. William H. Clapp to Dr. William Porter, May 12, 1947, Oakland Museum of California, Art Archives.

39. William Clapp Journal entry of October 5, 1939, Oakland Museum of California, Art Archives.

40. Nancy Boas to the author, March 1, 1998. A year later, however, on May 22, 1984, Siegrist wrote to Boas: "I enjoyed looking at his [Raphael's] work, but he didn't influence me much." It may be that Raphael's art impacted Bay Area modernism in a general way rather than specifically on the members of the Society.

41. *San Francisco Argonaut*, January 18, 1935, quoted in "Joseph Raphael," in Gene Hailey, ed., *California Art Research* (San Francisco, Calif.: Works Progress Administration, 1936–37), vol. 5, p. 38.

42. Bram Dijkstra, *American Expressionism. Art and Social Change 1920-1950* (New York: Harry N. Abrams, 2003), pp. 89–90.

43. H. L. Dungan, "Impressionist Exhibit Held in Oakland Gallery," *Oakland Tribune*, January 7, 1933. Oakland Museum of California, Art Archives, Raphael File.

44. Anna Cora Winchell, "Artists and Their Work," *San Francisco Chronicle*, October 31, 1920, p. 8S.

45. Raphael's *Apples* and, indeed, all his still lifes, are undated, but *Still Life* at Mills College was donated by Albert Bender in 1925. It is likely, therefore, that these pictures were painted about 1920 or in the early 1920s. On January 29, 1919, Raphael's wife had thanked Bender for an exquisite box of California fruits that had arrived a few days earlier. Raphael wrote to Bender on March 29, 1922: "This month I am digging and preparing my garden and as there is much rain, I paint still lifes, in sometimes one corner of our big room, or when I am tired out of that particular nook, I change my apparatus over into another angle." Special Collections, Mills College Library, Oakland.

46. Raphael, September 19, 1921, to Bender, Special Collections, Mills College Library, Oakland.

47. I am grateful to Jennifer Bienenstock for locating the information on Raphael's exhibitions of the 1920s and 30s and for discussing them with me. Dietrich & Co. was probably a Brussels firm.

48. Aline Kistler, "Fine Work by Raphael is on Display," *San Francisco Chronicle*, January 6, 1929, p. D-7.

49. Catherine Raphael's reminiscences, The Hague, 1985. Raphael Catalogue Raisonné Archives.

50. Raphael, Oegstgeest, May 3, 1933, to Bender, and Raphael, Italy (outside Genoa, where the artist's wife had gone for treatment), July 17, 1933, to Bender.

51. My appreciation is due again to Dr. Jennifer Bienenstock. Raphael may have held earlier exhibitions at "De Ploeg."

52. Catherine Raphael's reminiscences, The Hague, 1985, Raphael Catalogue Raisonné Archives.

53. Otto van Tussenbroek, "The Wood Cuts of Joe Raphael," *De Groene Amsterdammer*, December 26, 1931; translation in the Bender-Raphael correspondence, Special Collections, Mills College Library, Oakland.

54. Otto van Tussenbroek, "The Woodcuts of Joe Raphael" (translation by Johanna Raphael and Morgan Sibbett, August 12, 1979), *Op de Hoogte*, May 1933, pp. 136–40.

55. Raphael Catalogue Raisonné Archives.

56. Postcard announcement from the Oakland Museum of California Art Archives. See also H. L. Dungan, "Noted Artist to Exhibit in Local Art Gallery," *Oakland Tribune*, December 31, 1932, Oakland Museum of California, Art Archives.

57. The béguinages of the Low Countries were inhabited by nuns but were not subject to the religious authorities and were often made up of members of rich and noble families. A few years after Raphael painted the béguinage it became a monastery for the Benedictine sisters.

58. Glenn Wessels, "The Art World: Riviera Water-Colors," *Argonaut* 13 (January 18, 1935), p. 13.

59. Johanna Raphael's reminiscences, ca. 1985, Raphael Catalogue Raisonné Archives.

60. Raphael, November 29, 1933, to Bender, Special Collections, Mills College Library, Oakland.

61. Johanna Raphael's reminiscences, ca. 1985, p. 3, Raphael Catalogue Raisonné Archives.

62. "Joe Raphael Welcomed," *San Francisco Art Association Bulletin* 5 (June 1939), p. 3.

63. William Clapp to Selden Gile, February 15, 1943, Oakland Museum of California, Art Archives, Raphael File.

64. Alfred Frankenstein, "Around the Art Galleries," *San Francisco Chronicle*, December 17, 1939, p. 25; Alfred Frankenstein, "Around the Art Galleries," *San Francisco Chronicle*, December 24, 1939, p. 28.

65. "Joseph Raphael Display Shows Mature Personality," *San Francisco Examiner*, December 31, 1939, p. D-5.

66. *Golden Gate International Exposition San Francisco, 1940. Palace of Fine Arts. Art. Official Catalogue*, exh. cat. (San Francisco, Calif.: Recorder Printing and Publishing Co., H. S. Crocker Co., Inc., and Schwabacher-Frey Co., 1940), pp. 153, 164. To date, little has been located concerning the exhibition and reception of Raphael's Japanese Tea Garden series.

67. Alfred Frankenstein, "Art on Treasure Island: California Art in Retrospect," *San Francisco Chronicle*, August 25, 1940, p. 16.

68. The history of the Helgesen Gallery and its role in the promotion of modern art in the Bay Area would be a fascinating study, deserving of scholarly attention. It appears to have gone through several "phases," where its demise was continually "greatly exaggerated." In 1934 its closing was reported in the San Francisco press. See Glenn Wessels, "The Art World: Wood Cuts and Prints," *Argonaut* 113 (September 21, 1934), p. 13.

69. See, for instance, Alfred Frankenstein, "Around the Galleries," *San Francisco Chronicle*, October 19, 1941, p. 25. Frankenstein, as both art and music critic of the *Chronicle*, was especially drawn to Raphael's woodcuts, perhaps none more so than those depicting the Stern Grove concerts, such as *Ballet at the Stern Grove* (ca. 1941; private collection), reproduced by him "In the Realm of Music," *San Francisco Chronicle*, June 16, 1940, p. 26.

I.

EARLY FIGURATIVE WORKS PAINTED IN LAREN, HOLLAND, 1905–11

RAPHAEL came to Europe, trained by the Californian academic tenets of his day and formed by the brilliant light and atmosphere of his native landscape. During his first years he divided his time between Paris and the artists' colony of Laren, near Amsterdam. Living primarily in Laren, he painted mainly figurative compositions set indoors with artificial lighting. The most celebrated is his *La Fête du Bourgmestre* of 1905 (Cat. 1), which received an honorable mention in the Paris *Salon de la Société Nationale des Beaux Arts* (1906). There the painting was singled out for praise by the noted critic Paul Jamot, among others. In the work, Raphael combined a sense of drama and presentation reflective of Rembrandt's group portraits with the textural delineation and brushwork reminiscent of Velasquez, whose art he scrutinized in Spain, Italy, and Holland. By 1910, with his intimate portrait of *Mien de Leeuw* (Cat. 2), Raphael set his subjects *en plein air*.

Able to shift from large- to small-scale formats, the artist retained vibrancy and richness with his broad brushstrokes, whether in the flesh tones, silhouettes, or the overall feeling of openness and accessibility of the images.

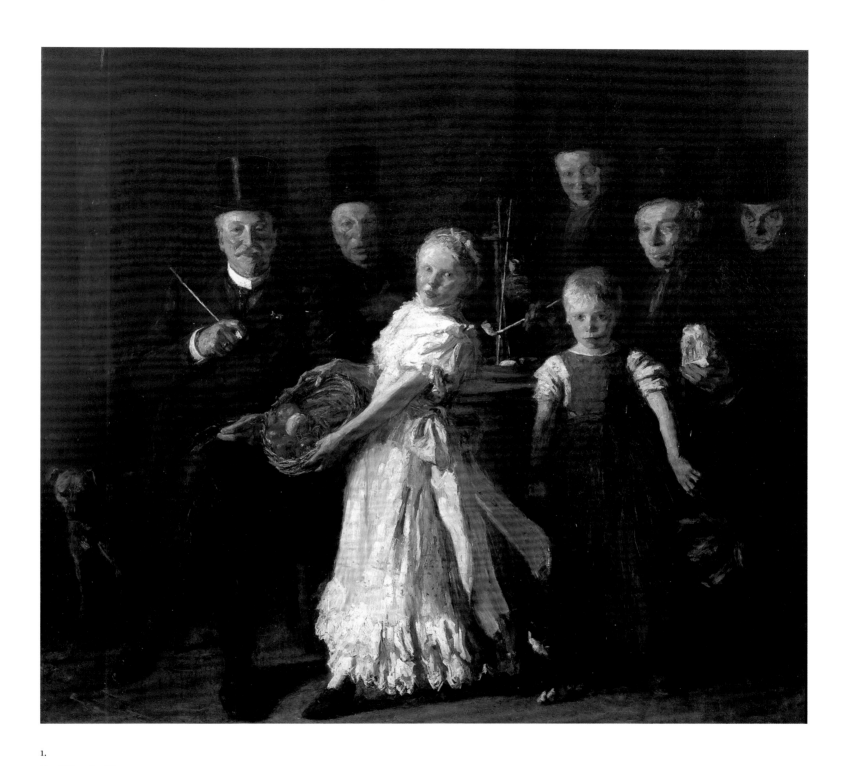

1.

La Fête du Bourgmestre, ca. 1905

Oil on canvas
80½ × 89½ inches
Signed, dated, and inscribed on verso: *1905 / Donor Stuart
Loomes, 2507 Pacific Ave. / Sincerely Jos Raphael, Aug. 1910*
Private Collection

2.

Mien de Leeuw, 1910

Oil on board
10 × 7½ inches
Signed and dated lower left: *'J. Raphael.' / 1910*
Private Collection

3.

Dutch Landscape: Windmill and Sky, ca. 1909

Oil on panel
5¾ × 8⁷⁄₁₆ inches
Signed lower left: *Raphael*

II.

FLOWERING FIELDS, BELGIUM AND HOLLAND, 1912–18

BY 1912, Joseph Raphael was a married man, residing in the rural suburb of Brussels known as Uccle with his Dutch wife and two toddlers. No longer a member of the bachelor/artists' club of Laren, he was eager to explore his new surroundings. Often with his young family, he would travel to the tulip countryside of Noordwijk, Holland, a train ride of a few hours from Brussels. There, identifying with the young van Gogh, he positioned himself in the midst of the flowering fields of tulips, hyacinths, or rhododendrons and painted some of his most esteemed landscapes. Having grown up in California with a love of nature, he was in his element, using a range of thickly loaded brushes to convey the sensuous rhythms and sun-filled atmosphere of repeated rows of petals.

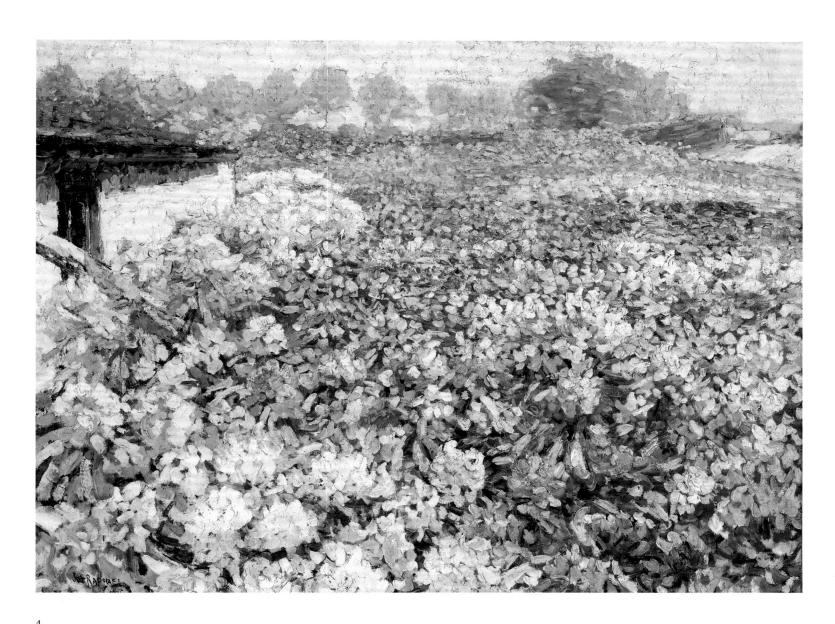

4.

Rhododendron Fields (Belgium), 1915

Oil on canvas
30 × 40 inches
Signed and dated lower left: *Jos Raphael / 1915*
The Oakland Museum of California,
Gift of Dr. William S. Porter

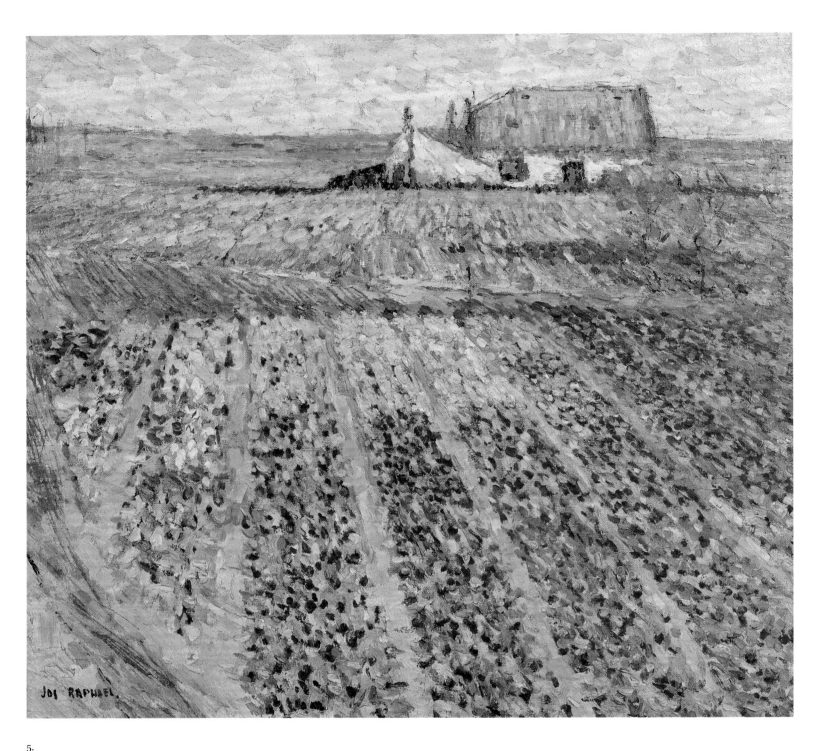

5.

Tulip Fields at Noordwijk (Holland), ca. 1912

Oil on canvas
26½ × 28¼ inches
Signed lower left: *Jos Raphael.*
Private Collection

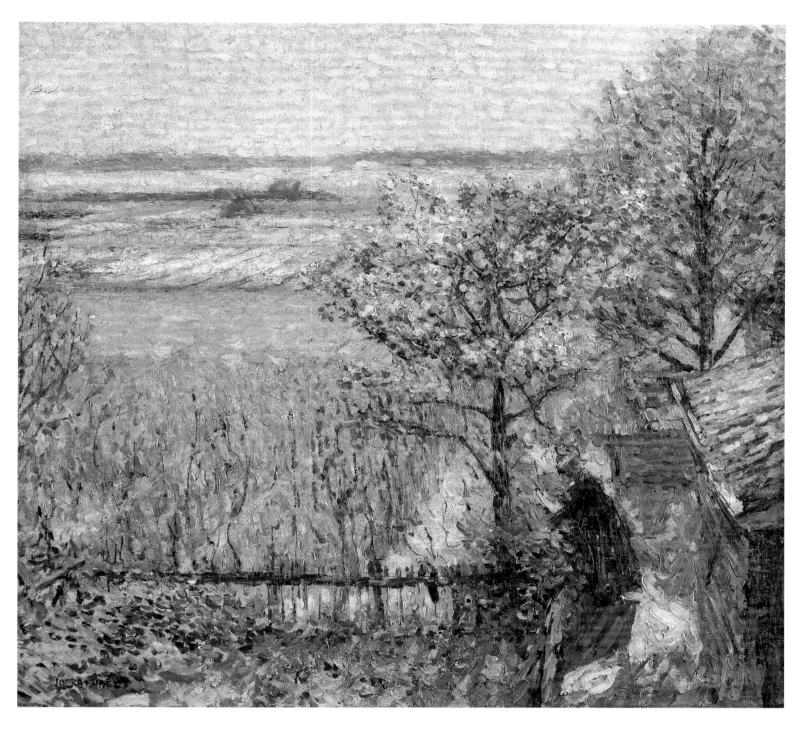

6.

Fields and Flowering Trees (Noordwijk, Holland), ca. 1912

Oil on canvas
27½ × 30 inches
Signed lower left: *Jos Raphael*
Mort and Donna Fleischer Collection

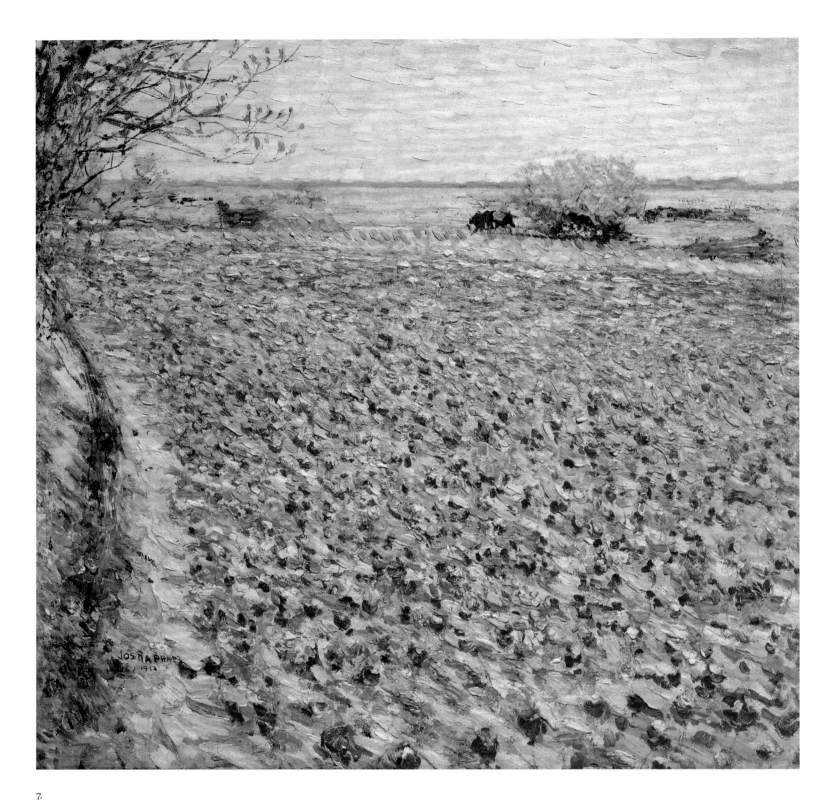

7.

Tulip Field in Holland, 1913

Oil on canvas
29½ × 29½ inches
Signed and dated lower left: *Jos Raphael / 1913*
Iris & B. Gerald Cantor Center for Visual Arts,
Stanford University, California,
Gift of Morgan Gunst Conservation, supported by
the Lois Glumeck Fund

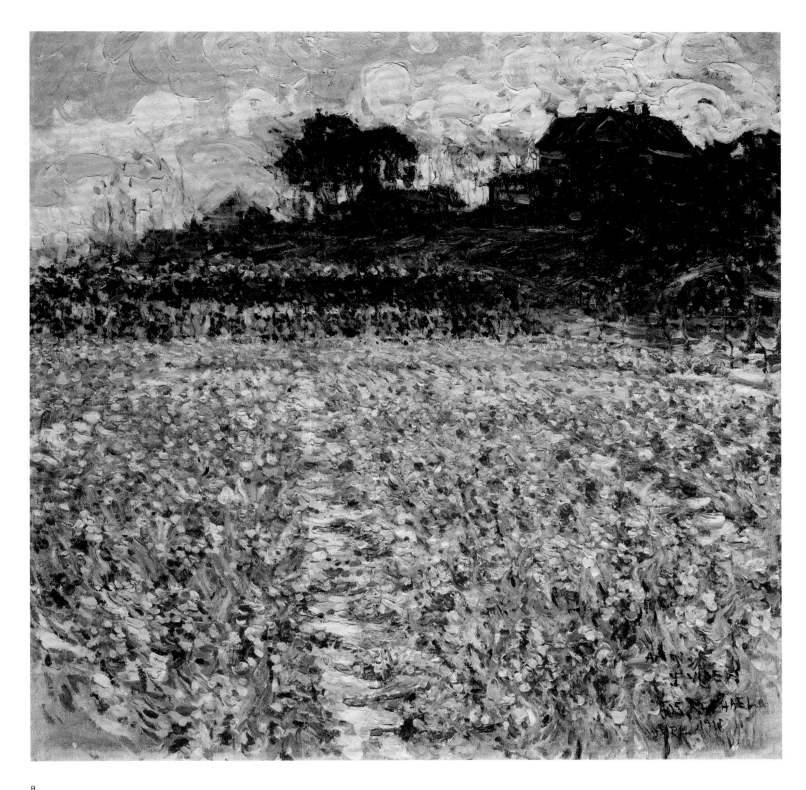

8.

Flowering Fields, Noordwijk (Holland), 1915

Oil on canvas
31½ × 31½ inches
Signed, dated, and inscribed lower right:
Aan / J. Viden / Jos Raphael / April 1915
Private Collection

9.

Autumn View of Papekasteel from
Artist's Garden (Belgium), 1914

Oil on canvas
31 × 39 inches
Signed and dated lower left: *Jos Raphael / Nov 1914*
Private Collection

10.

Fields near St. Job (Uccle, Belgium), 1915

Oil on canvas
17¾ × 27¼ inches
Signed and dated lower right: *Jos. Raphael / 1915*
Mort and Donna Fleischer Collection

11.

Spring Winds, Noordwijk (Holland), ca. 1912

Oil on canvas
29¼ × 36⅛ inches
Signed lower right: *Jos. Raphael*
Fine Arts Museums of San Francisco, Museum purchase,
Skae Fund Legacy

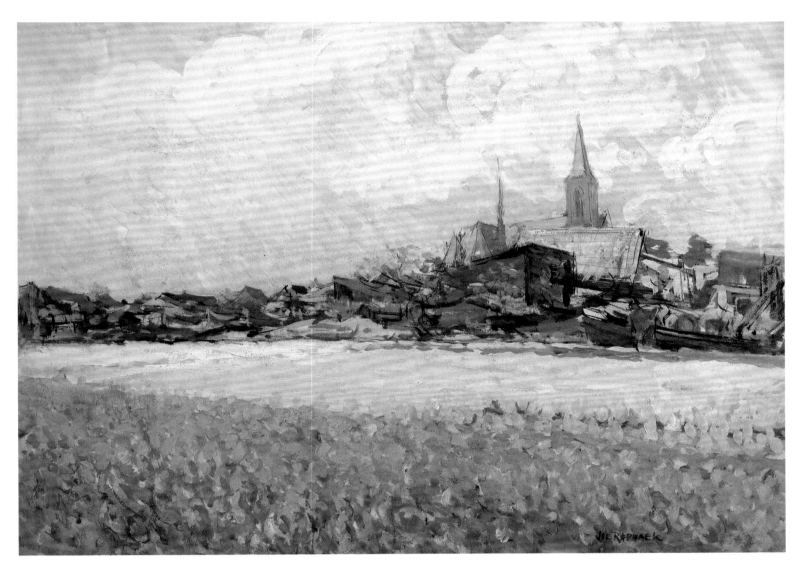

12.

Hyacinth Fields, Noordwijk (Holland), ca. 1918

Tempera with ink on paper
22 × 30½ inches
Signed lower right: *Joe Raphael*
Oscar and Trudy Lemer Collection

III.

STREAMS, PONDS, AND FRUIT TREES,
BELGIUM, 1912–18

ARMED with canvas, paints, brushes, and palette, Raphael would prop himself in his garden or in the nearby cherry orchards of Kriekeput and Uccle (Belgium) to capture in oil the light, texture, and "fragrance" of the flowering fruit trees. He could combine his keen observation of these blossoms with a power of draftsmanship that enabled him to distinguish one view from another, never repeating the same angle of vision or proximity to his subject.

Down the street from his home was the château known as Papekasteel (Pope's Castle), where Raphael was welcome to paint the stream, trees, and garden (Cat. 18). The ponds in the neighborhood, with their weeping willows and billowing poplars, magnetized him, their natural forms and lines creating echoing reflections. His compositions contain parallels of a motif viewed directly in front of the artist and its mirrored patterns delineated below, recalling Mondrian's landscapes of a few years earlier.

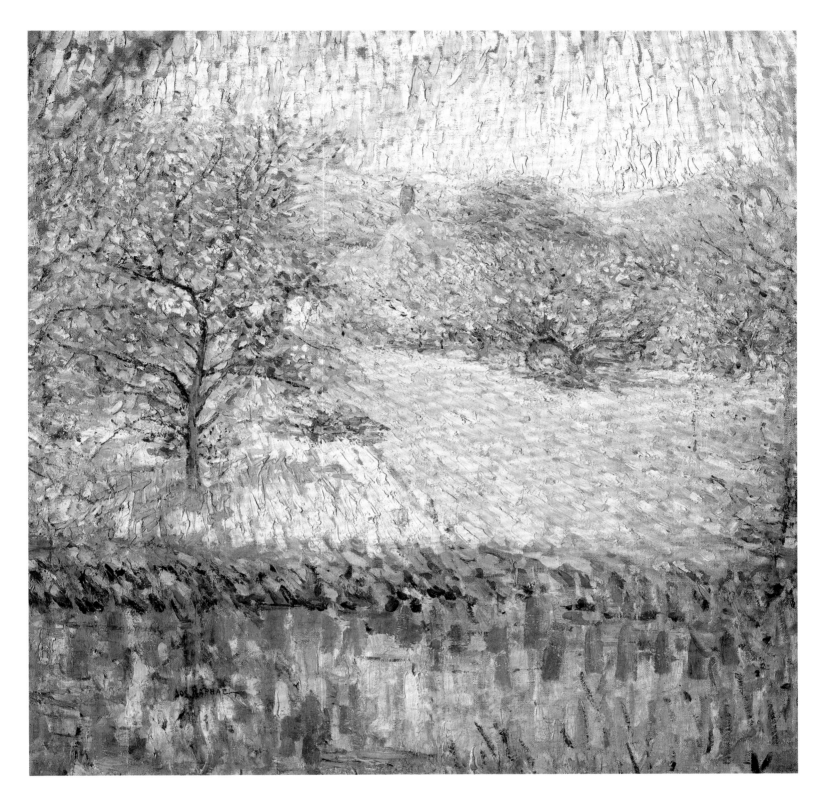

13.

Pond with Flowering Trees (Belgium), ca. 1912

Oil on canvas
30⅛ × 30⅛ inches
Signed lower left: *Jos Raphael*
Elizabeth S. and Alvin I. Fine Museum,
Temple Emanu-El, San Francisco

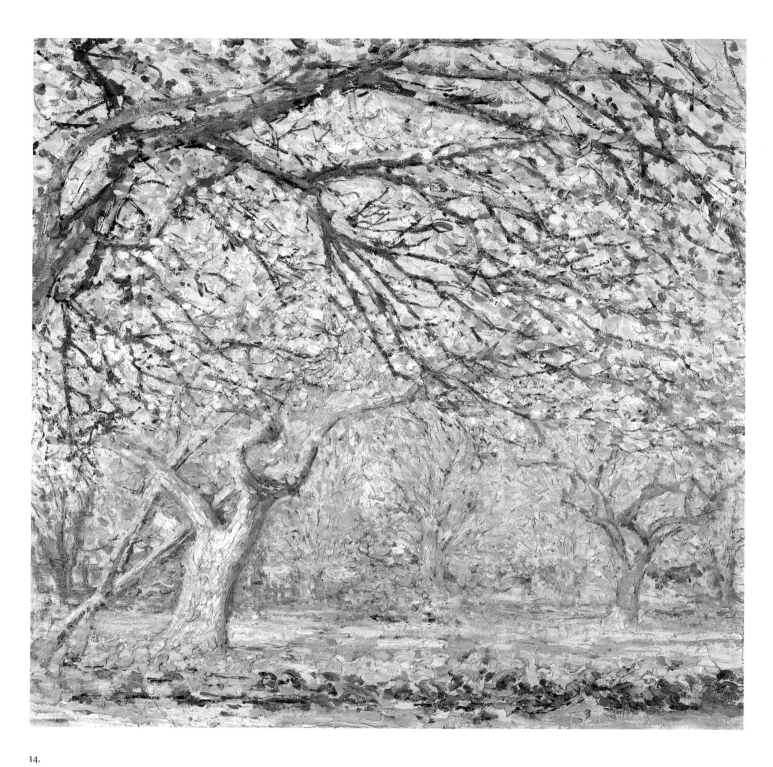

14.

Amidst Flowering Trees (Belgium), ca. 1913

Oil on canvas
30 × 30 inches
Signed lower left: *Jos Raphael*
Private Collection

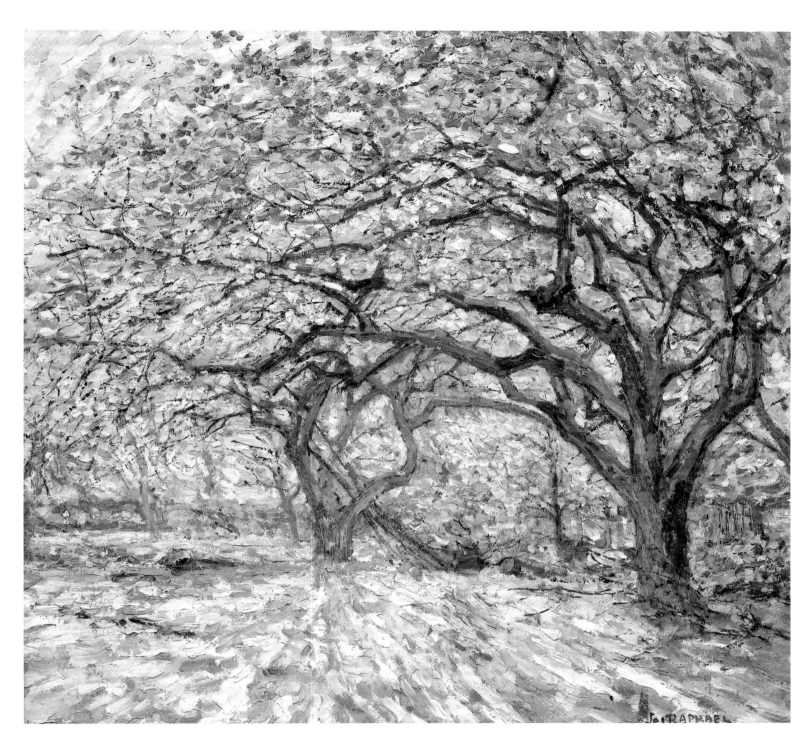

15.

Flowering Fruit Trees (Belgium), ca. 1913

Oil on canvas
29 × 30¾ inches
Signed lower right: *Jos Raphael*
Iris & B. Gerald Cantor Center for Visual Arts at Stanford
University, California, Gift of the Estate of Reba Grosse

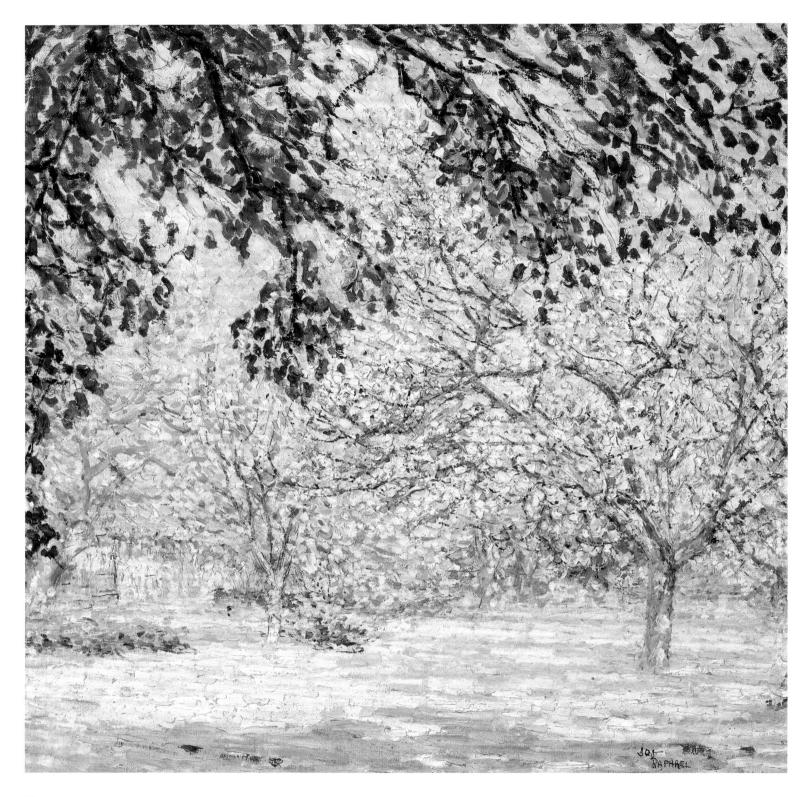

16.

Orchard from beneath the Tree (Belgium), ca. 1913

Oil on canvas
30½ × 30¾ inches
Signed lower right: *Jos. / Raphael*
Private Collection

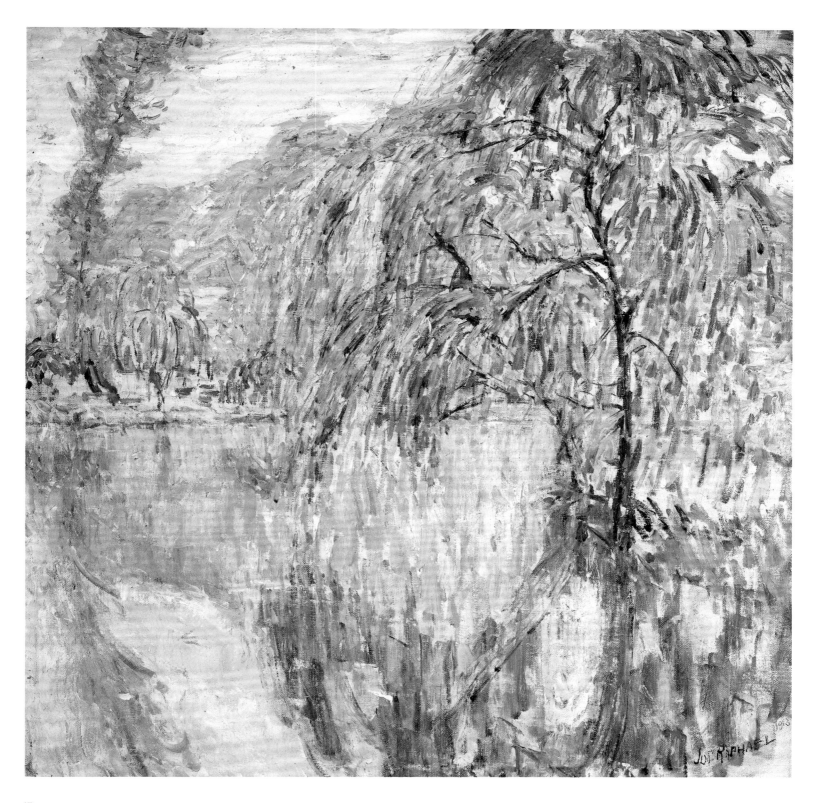

17.

Pond with Willow Tree (Belgium), 1913

Oil on canvas
30¼ × 30¼ inches
Signed and dated lower right: *Jos Raphael / 1913*
Private Collection

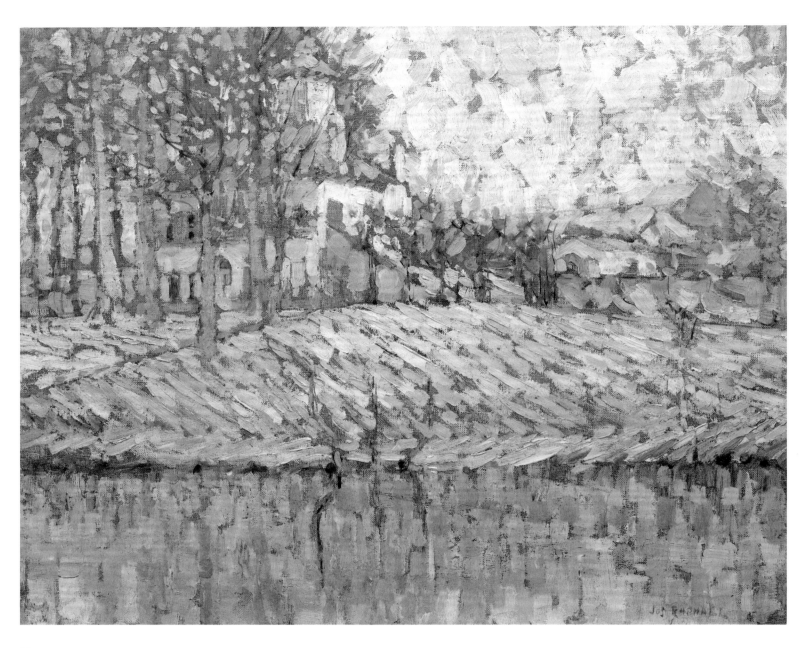

18.

By the Stream (Papekasteel, Uccle, Belgium) ca. 1915

Oil on canvas
22 × 27⅛ inches
Signed lower right: *Jos Raphael*

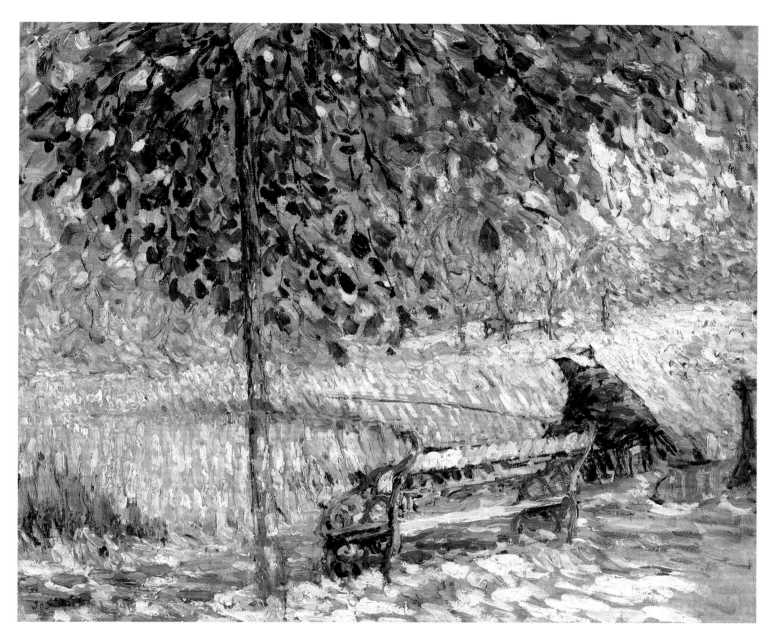

19.

Fishing in the Garden of Papekasteel (Belgium), 1918

Oil on canvas
20 × 24 inches
Signed and dated lower left: *Jos Raphael 1918*
Private Collection, San Francisco

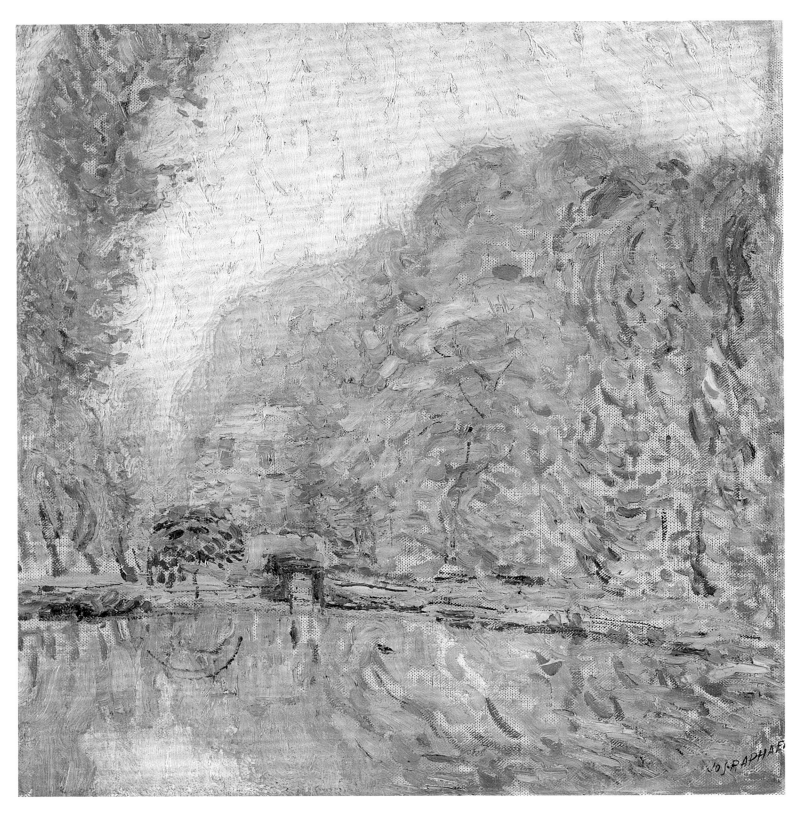

20.

Pond and Trees (Belgium), ca. 1914

Oil on canvas
17 × 16⅛ inches
Signed lower right: *Jos. Raphael*
Private Collection

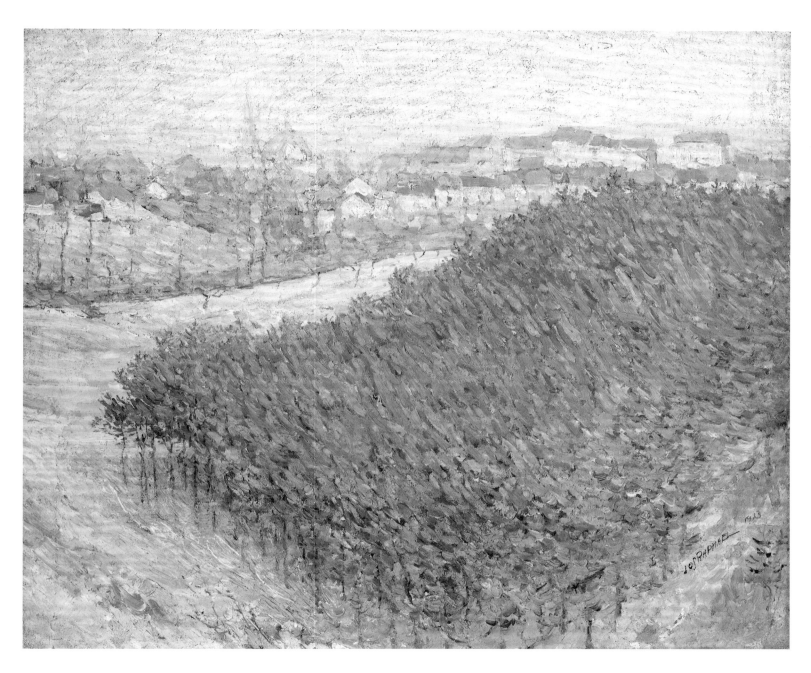

21.

View of the Hills near Uccle (Belgium), 1913

Oil on canvas
24½ × 29¼ inches
Signed and dated lower right: *Jos Raphael 1913*
Oscar and Trudy Lemer Collection

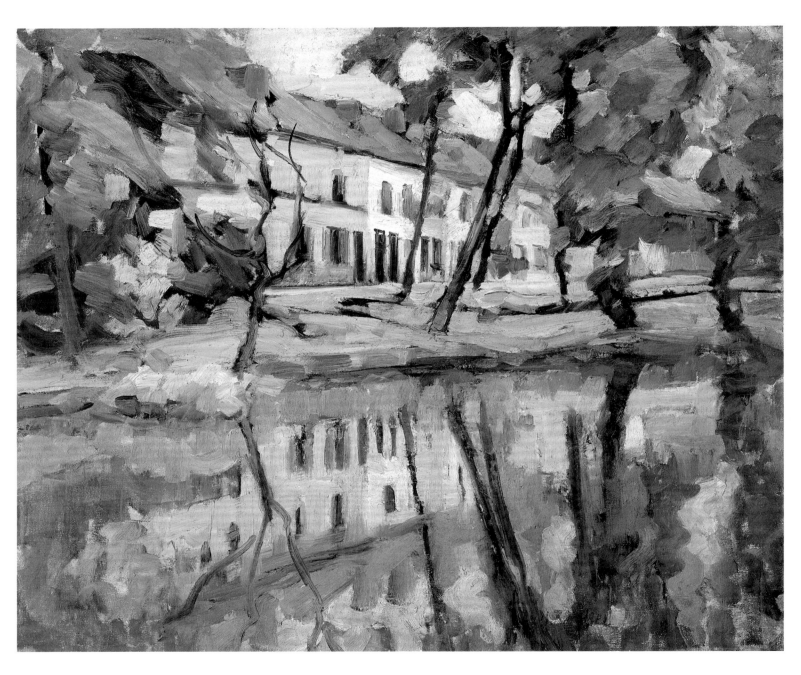

22.

At Mr. Wiggins's (Uccle, Belgium), ca. 1917

Oil on canvas
26 × 30½ inches
Inscribed on verso: *At Mr. Wiggins*
Oscar and Trudy Lemer Collection

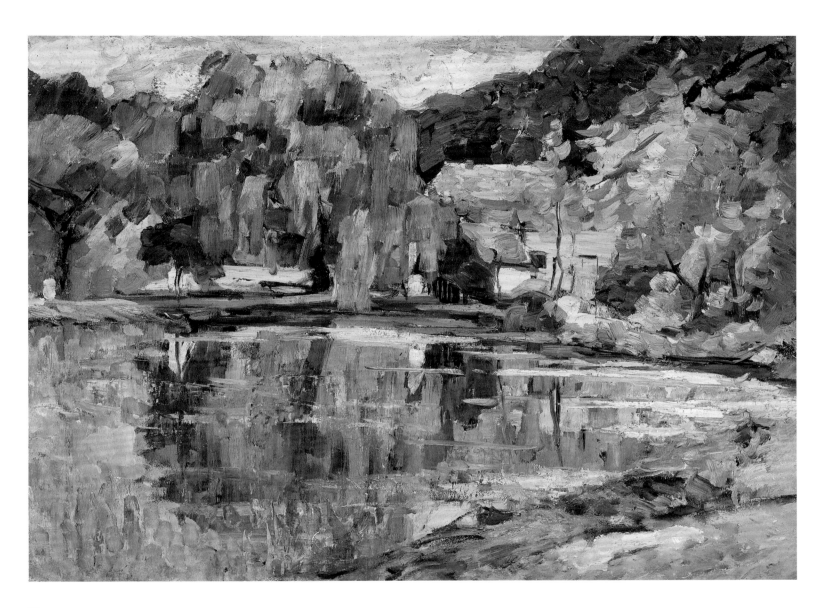

23.

The Old Mill Pond (Belgium), ca. 1918

Oil on canvas
27 × 37 inches
Private Collection

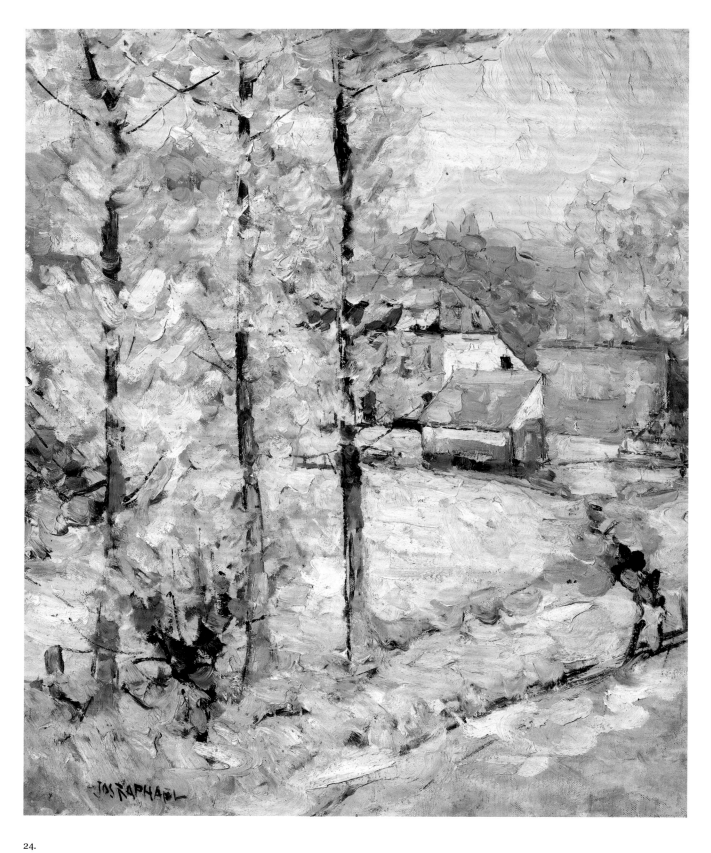

24.

Poplars in Autumn (Uccle, Belgium), ca. 1914

Oil on canvas
23 × 19 inches
Signed lower left: *Jos Raphael*
Private Collection

(Detail opposite)

IV.

PAINTING DURING AND IN THE AFTERMATH OF WORLD WAR I, BELGIUM, 1913–26

During the war years, Raphael's brushwork became more open and his powers of characterization more acute. He chose subjects that were either personal—everyday scenes of his family in their garden, swathed in a warm, comforting light—or that documented human responses to the disturbing wartime events and dire conditions surrounding him.

Throughout this period, when art materials were scarce, Raphael sometimes painted on the verso of earlier canvases and turned to working on paper. As his brushwork with oil paint became freer and more expressive, his draftsmanship focused on detail. He varied his lines with pointillist stippling, creating lace-like textures, whether in pen and India ink or on the etched plate. By the mid-1920s, Raphael had gravitated toward woodblock printing, an art form that encouraged him to combine his painterly instincts with his supreme control of line, now delineated with one knife.

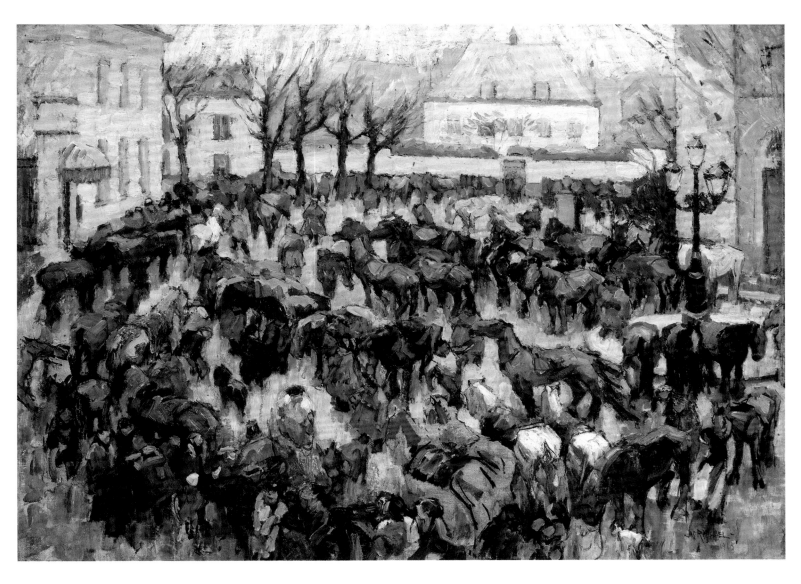

25.

Requisition of Horses, Uccle Town Square, 1915

Oil on canvas
34¼ × 47 inches
Signed and dated lower right: *Jos Raphael – / 1915*
Private Collection

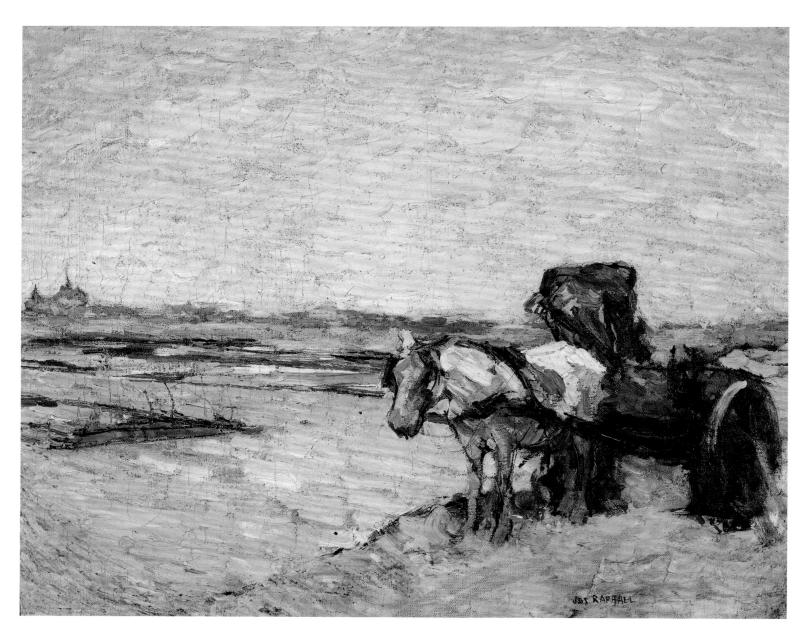

26.

Landscape with Horse and Cart,
Noordwijk (Holland), ca. 1912

Oil on canvas
23½ × 29½ inches
Signed lower right: *Jos Raphael*
Monterey Museum of Art, California,
Gift of Robin and Chris Sawyer

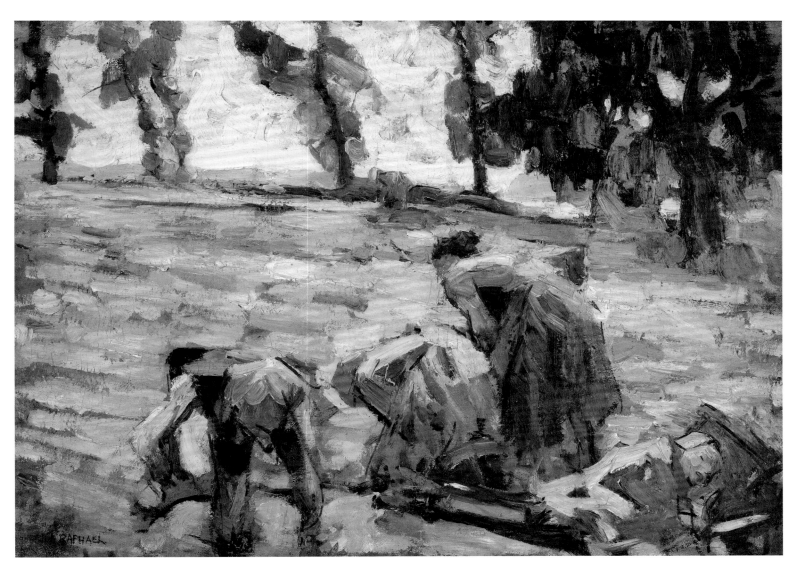

27.

The Potato Diggers, ca. 1913–14

Oil on canvas
23 × 31½ inches
Signed lower left: *Joe Raphael*
Oscar and Trudy Lemer Collection

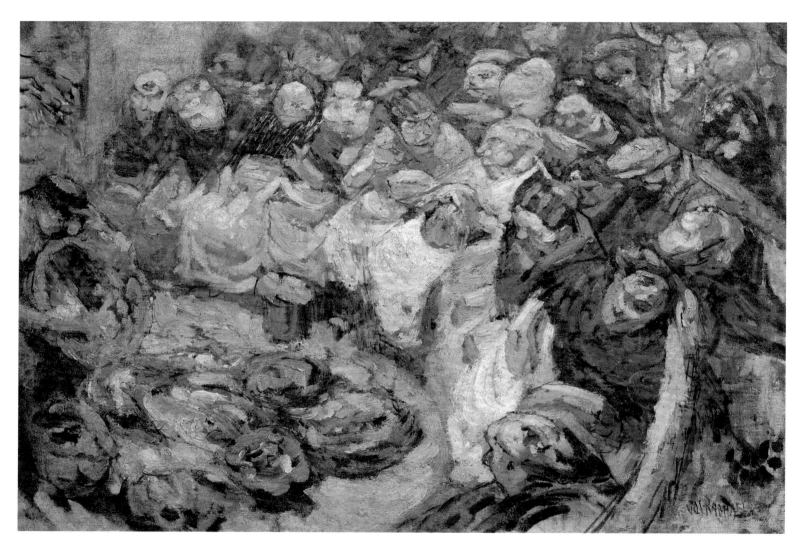

28.

Fish Buyers (Fish Market, Brussels), ca. 1918

Oil on canvas
21¾ × 32½ inches
Signed lower right: *Jos Raphael*

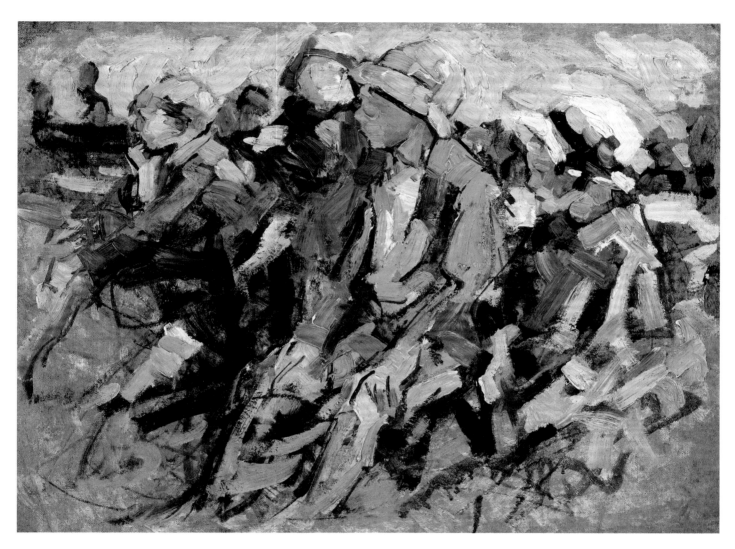

29.

Neighbors (Belgium), ca. 1918

Oil on canvas
19¾ × 26 inches
Private Collection

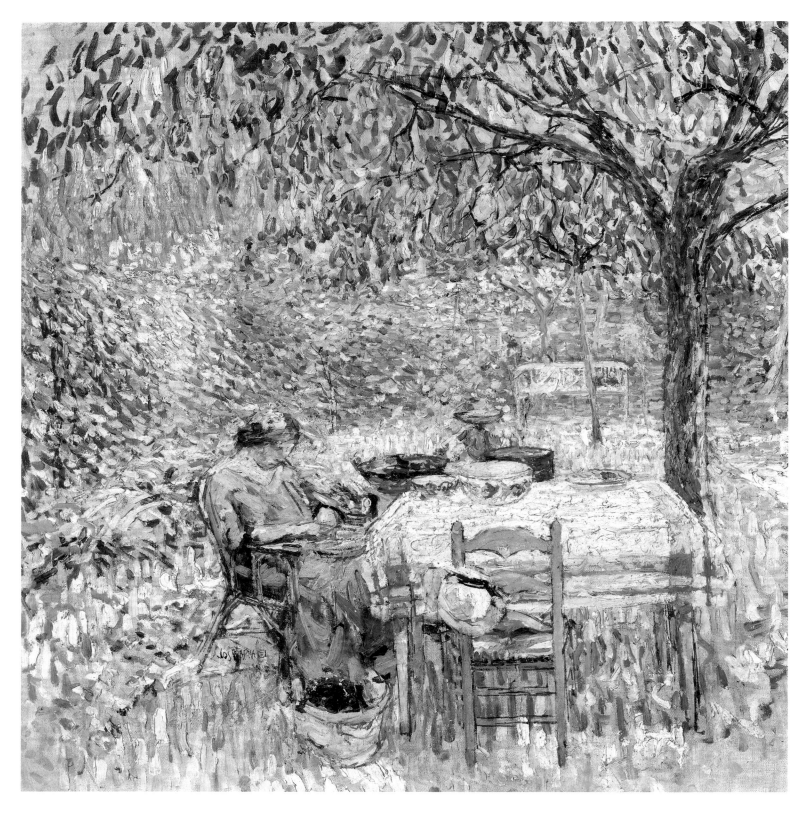

30.

Artist's Wife in Garden (Belgium), 1913

Oil on canvas
31¼ × 30¼ inches
Signed and dated lower left-center: *Jos Raphael 1913*
Private Collection

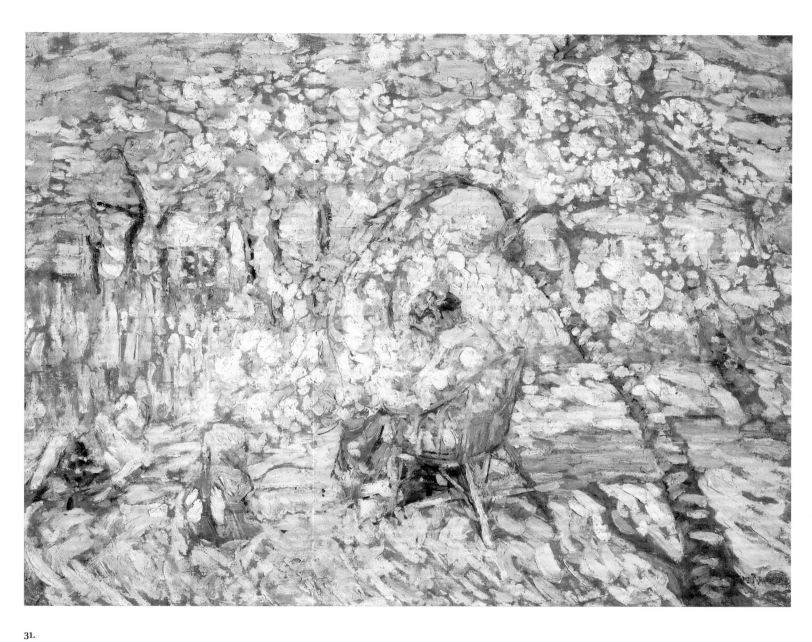

31.

*Artist's Wife with Her Children in the
Garden (Belgium)*, ca. 1913

Oil on canvas
27¾ × 36 inches
Signed lower right: *Joe Raphael*
Private Collection

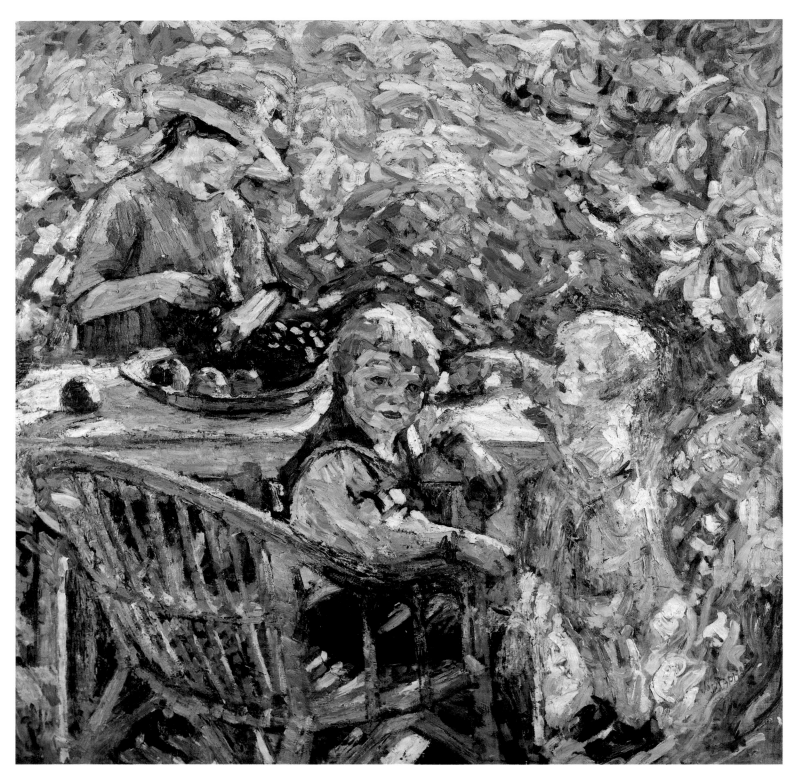

32.

In the Orchard, Belgium, ca. 1917

Oil on canvas
58½ × 58½ inches
Signed lower right: *Jos Raphael*
Mort and Donna Fleischer Collection

33.

Artist's Children at Play (Study of Liz, Dan, and Yo), ca. 1924

Oil on canvas
31 × 39 inches
Signed lower left-center: *Joe Raphael*
Oscar and Trudy Lemer Collection

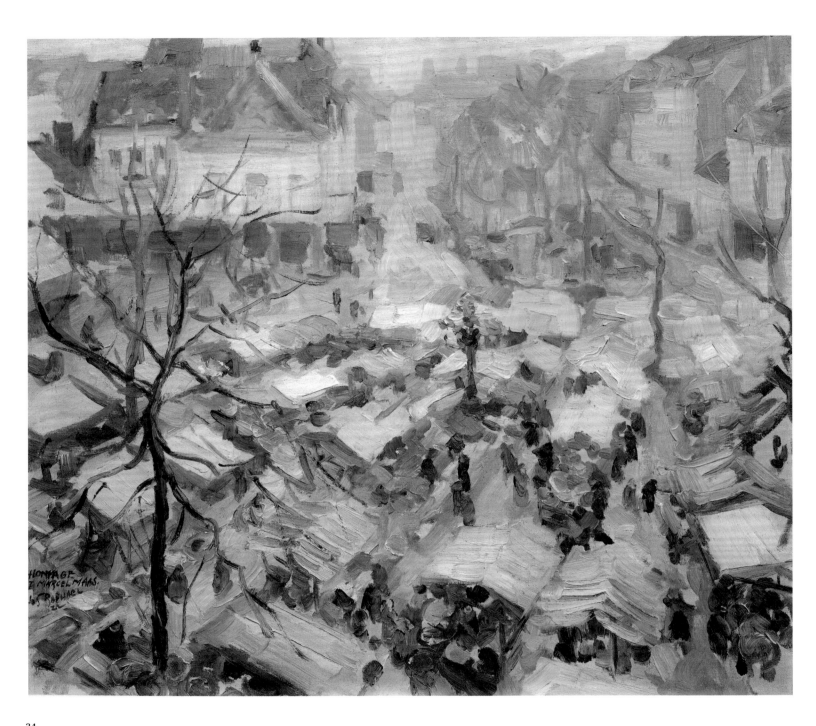

34.

View of Marché, Ste. Catherine, Winter (Belgium), 1922

Oil on canvas
26¼ × 29¼ inches
Signed, dated, and inscribed lower left:
Hommage /à / Marcel Maas. / Jos Raphael / 22
Private Collection

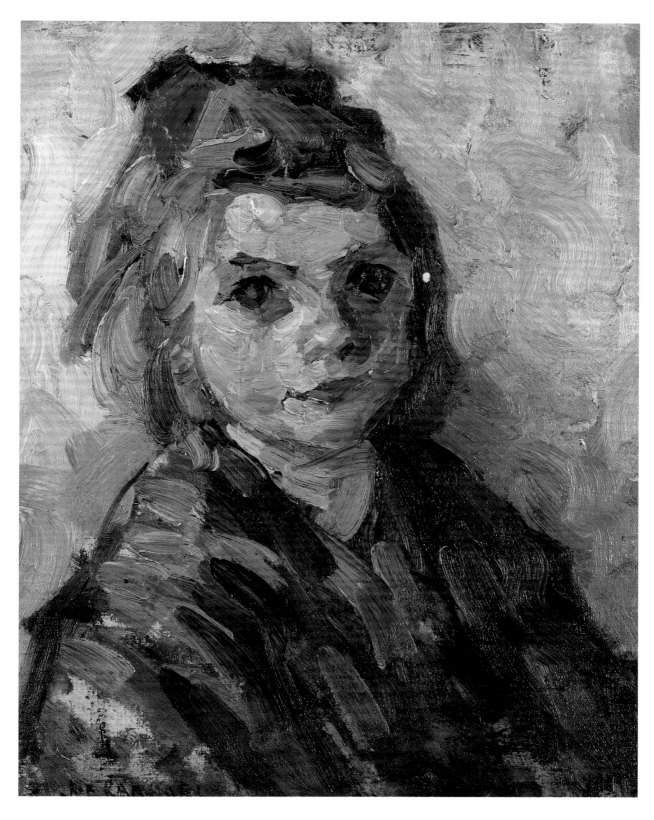

35.

Portrait of Johanna, the Artist's Daughter, ca. 1924

Oil on canvas
17¼ × 13¾ inches
Signed lower left: *Joe Raphael*
Monterey Museum of Art, California, Gift from the Collection of
Alva A. Christensen and Helen B. Christensen

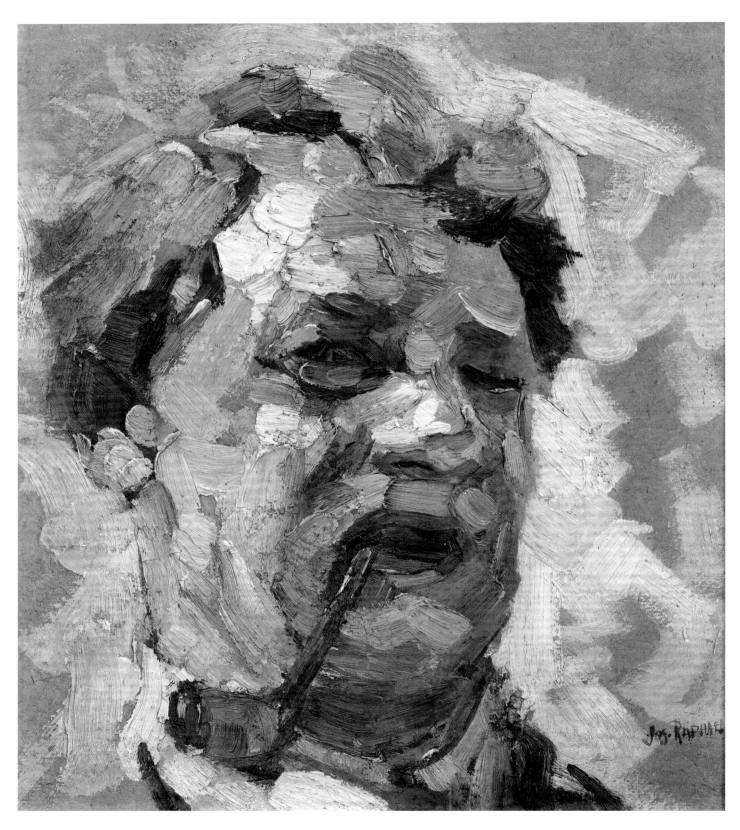

36.

Self-Portrait with Pipe, 1916

Oil on board with pinholes in corners
14½ × 12½ inches
Signed lower right: *Jos. Raphael*

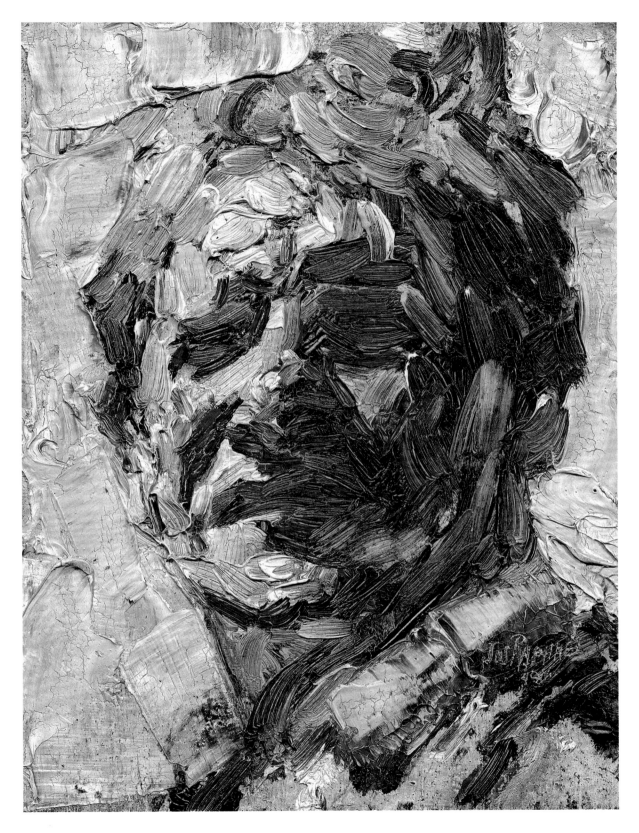

37.

Self-Portrait, 1916

Oil on panel (cigar box top)
7¼ × 5⅜ inches
Signed and dated lower right: *Jos Raphael / 1916*
Private Collection

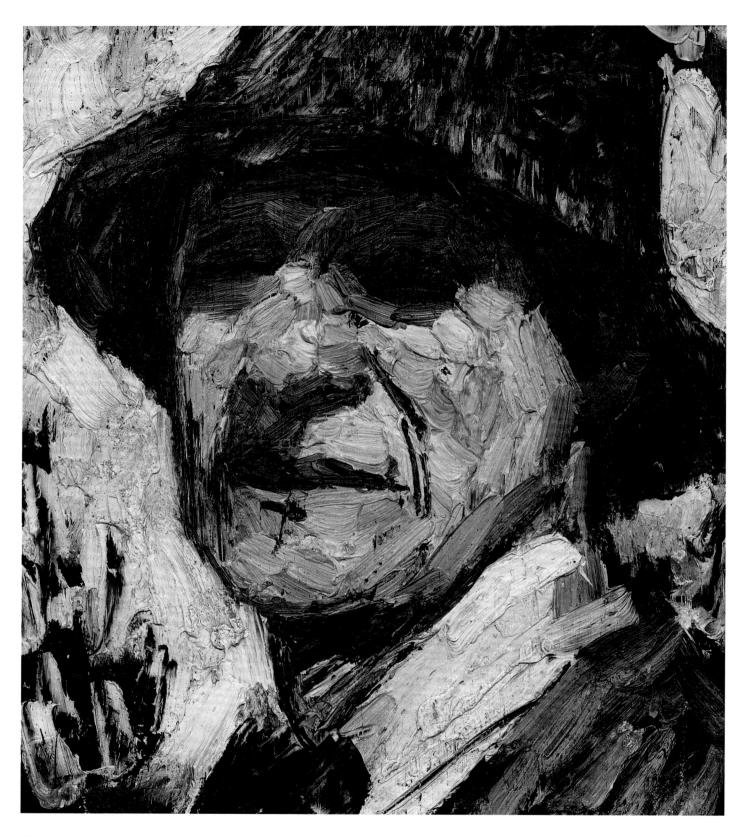

38.

Self-Portrait with Hat, ca. 1916

Oil on panel
7⅝ × 6⅞ inches
Signed lower center: *Jos Raphael*
Private Collection

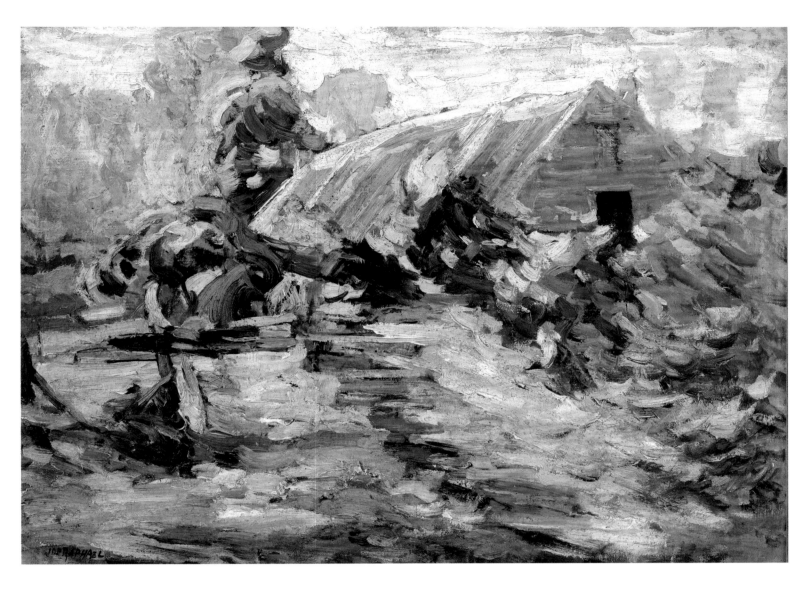

39.

Mill at Linkebeek (Belgium), ca. 1916

Oil on canvas
27½ × 38½ inches
Signed lower left: *Joe Raphael*
Oscar and Trudy Lemer Collection

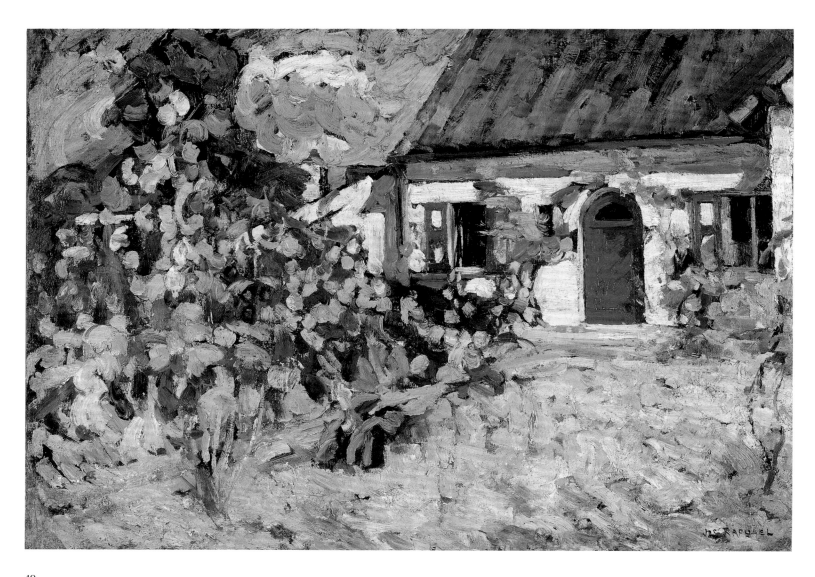

40.

The New Blue Door (Belgium), ca. 1923

Oil on canvas
27 × 38 inches
Signed lower right: *Jos Raphael*
Private Collection

(Detail opposite)

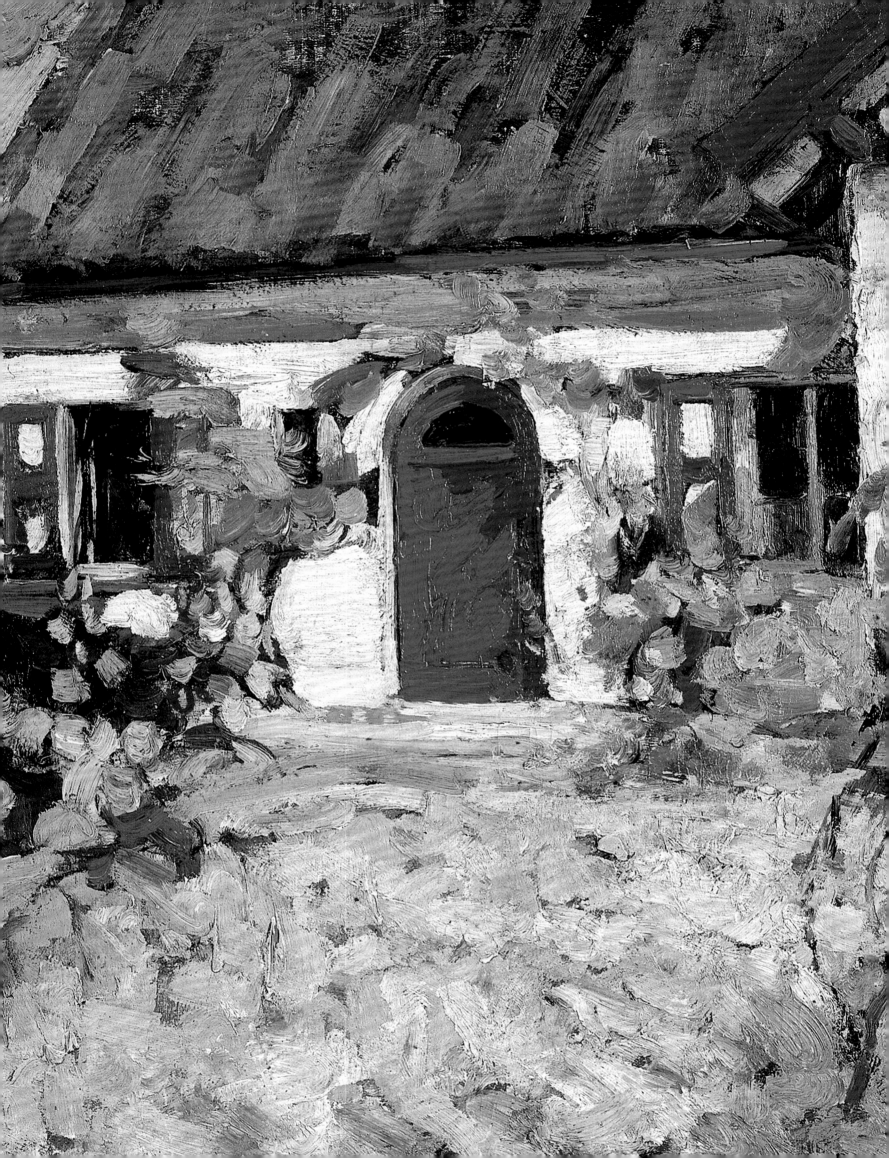

V.

STILL-LIFE PAINTINGS, UCCLE, BELGIUM, 1918–22

"THIS MONTH I am digging and preparing my garden and, as there is much rain, I paint still lifes, in sometimes one corner of our big room or, when I am fired out of that particular nook, I chase my apparatus over into another angle. On a Thursday or Saturday afternoon, when they [his children] are all home from school, and it's bad weather, it is horrible!" So wrote Raphael to his friend Albert M. Bender on March 29, 1922, expressing his means of continuing work despite inclement weather and distracting conditions indoors (before building his long-awaited studio in the new wing). In his approximately twenty extant still-life paintings from this period are fruit, vegetables, and flowers from his garden, combined with goblets, jars, and vases from his home.

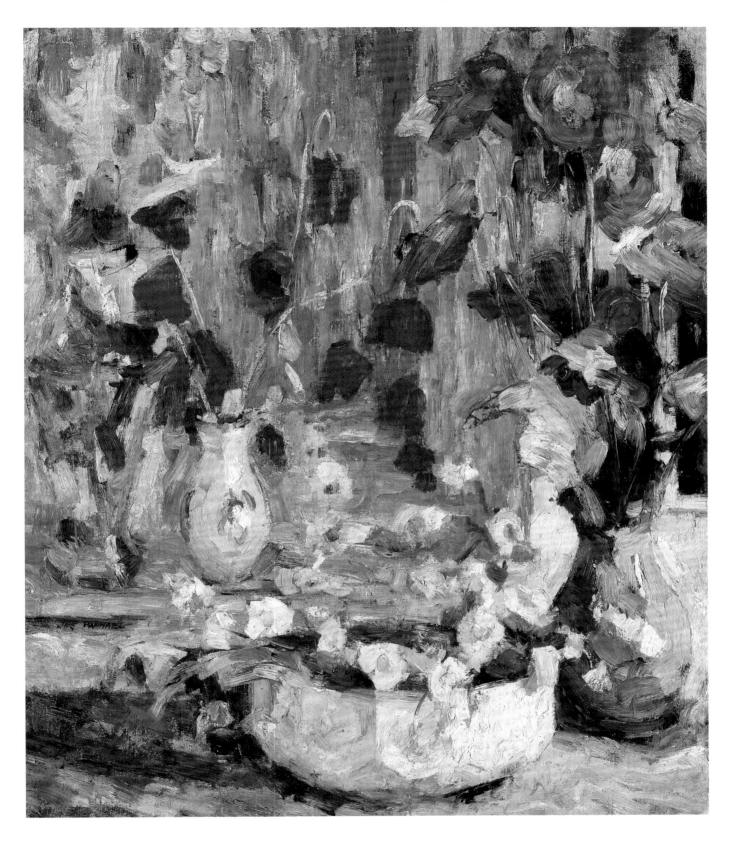

41.

Still Life with Red Poppies, ca. 1921

Oil on canvas
39⅜ × 33¼ inches
Signed lower left: *Joe Raphael*
Private Collection

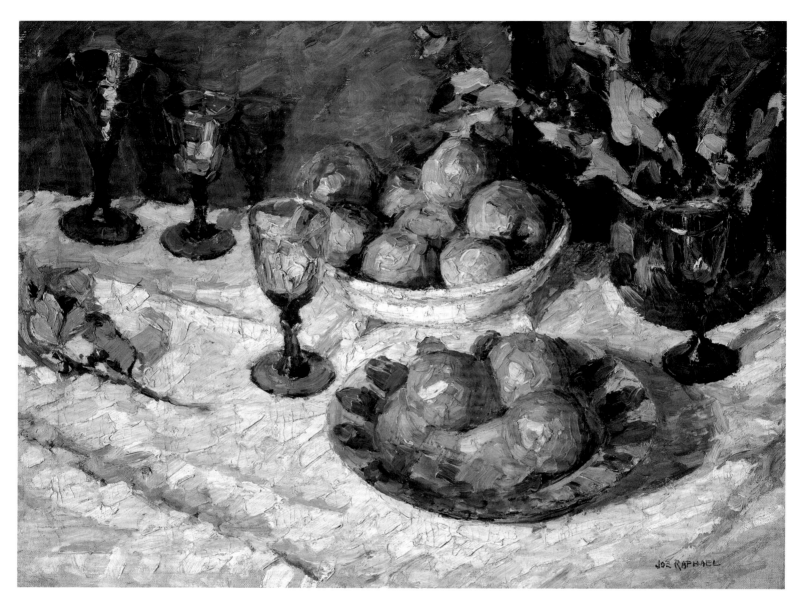

42.

The Christmas Table (Apples with Oranges on Blue Plate), ca. 1921

Oil on canvas
26 × 33 inches
Signed lower right: *Joe Raphael*
Oscar and Trudy Lemer Collection

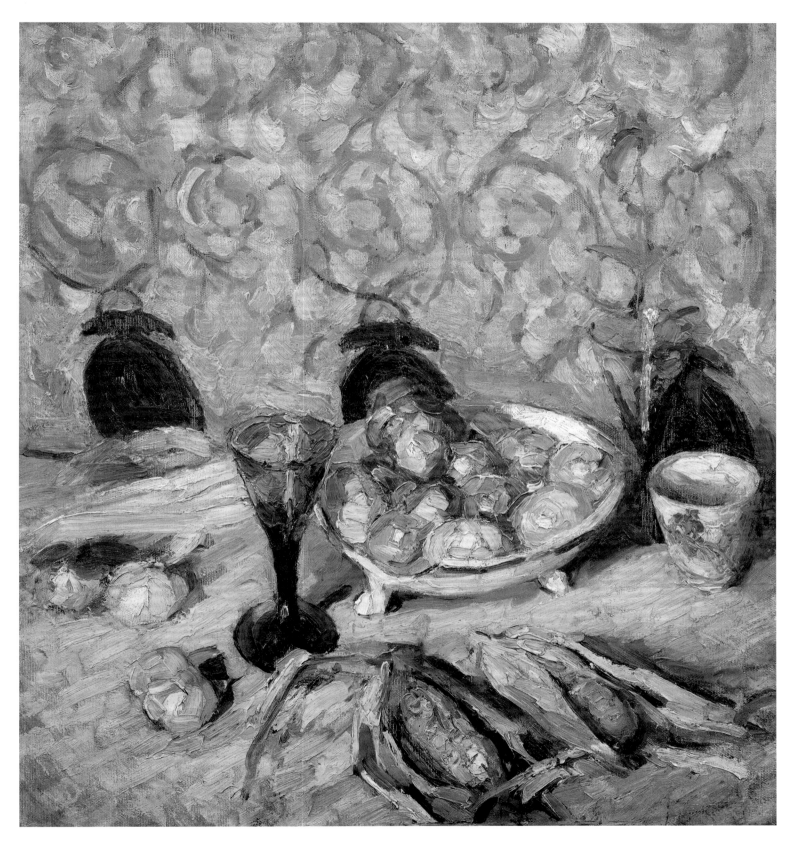

43.

Still Life with Goblets, Fruit, and Corn, ca. 1921

Oil on canvas
28⅛ × 25⅝ inches
Estate stamp on verso

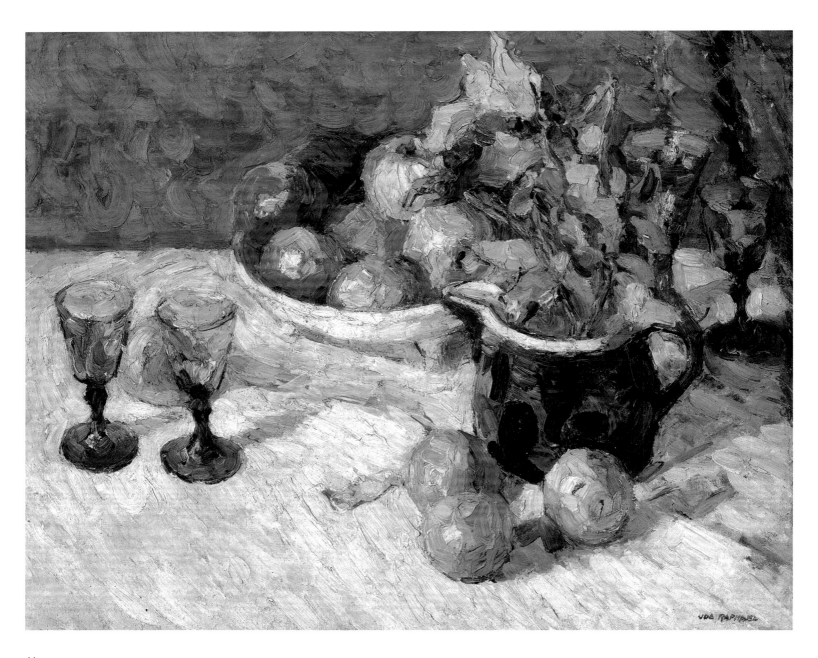

44.

Still Life with Apples and Oranges on Table, ca. 1921

Oil on canvas
26 × 32 inches
Signed lower right: *Joe Raphael*
Oscar and Trudy Lemer Collection

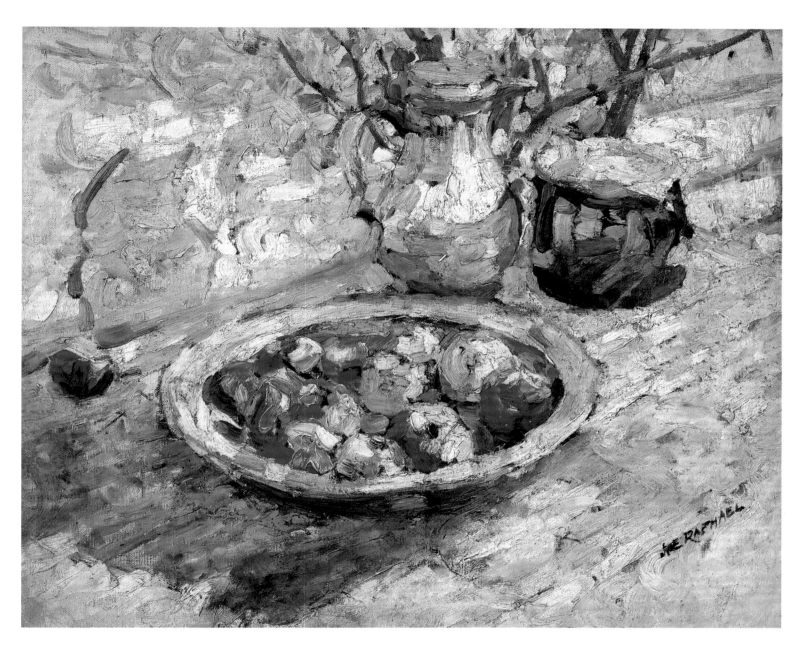

45.

Still Life with Bowl of Apples, Jug, and Pitcher, ca. 1921

Oil on canvas
26½ × 31½ inches
Signed lower right: *Joe Raphael*
Oscar and Trudy Lemer Collection

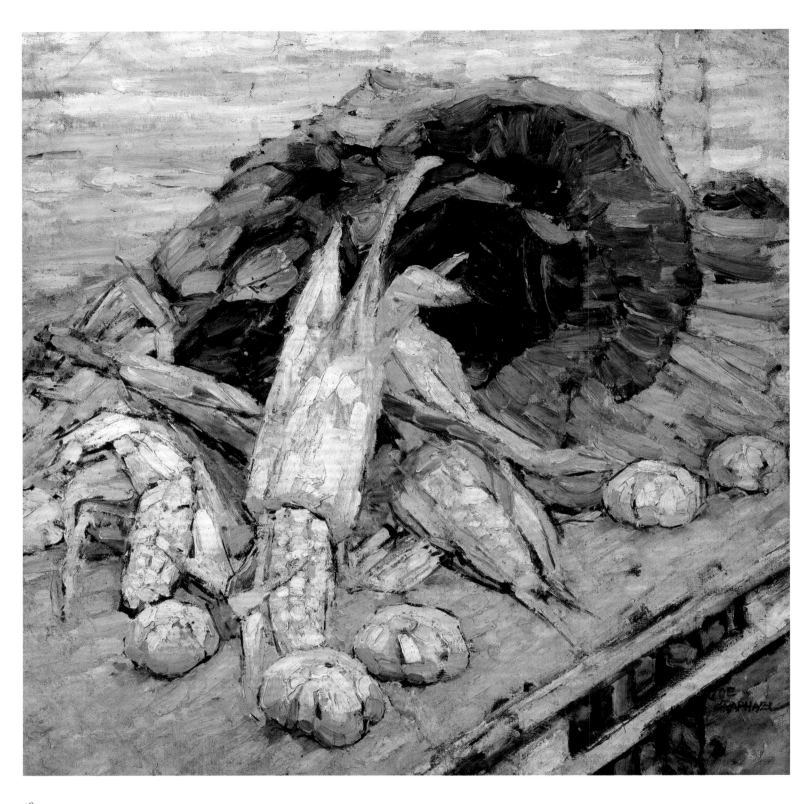

46.

Still Life with Corn Husks and Cabbage, ca. 1921

Oil on canvas
31½ × 31½ inches
Signed lower right: *Joe / Raphael*
Oscar and Trudy Lemer Collection

(Detail opposite)

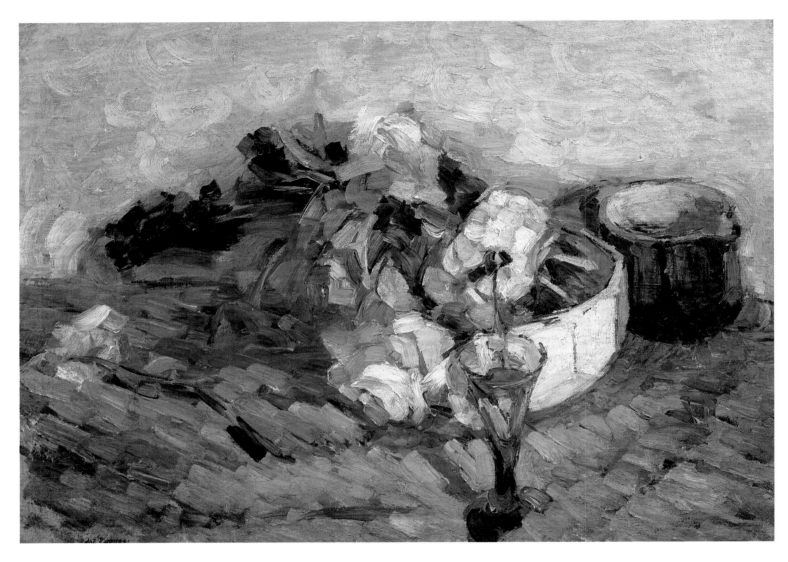

47.

Still Life with Flowers, ca. 1921

Oil on canvas
27½ × 37½ inches
Signed lower left: *Joe Raphael*

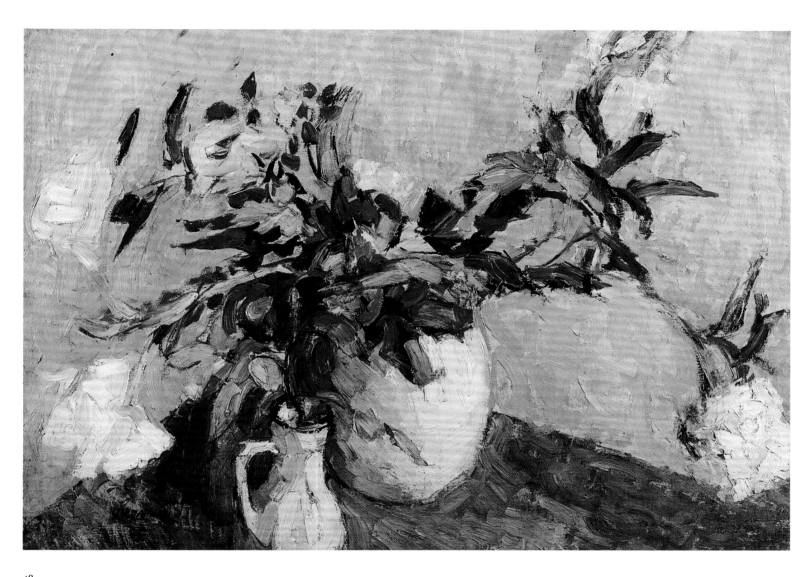

48.

Peonies and Rose, ca. 1921

Oil on canvas
29 × 39⅜ inches
Signed lower left: *Joe Raphael*

VI.

BRUGES, SUMMER AND FALL, 1932

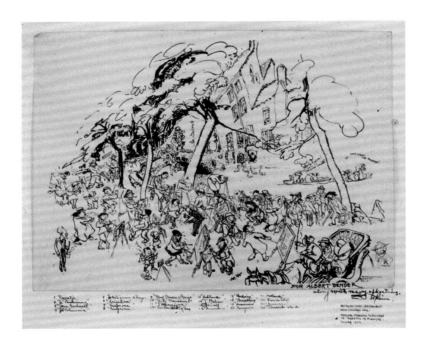

By 1932, Raphael and his family were settled in their Dutch home in Oegstgeest, a popular suburb of Leiden, near the University and its garden Hortus Botanicus where he often went to draw and paint. Alternatively, he would escape across the border to Bruges, Belgium, sometimes without warning, doubtless to avoid personal problems at home caused in part by the ongoing worldwide depression. In Bruges, the artist captured the life of this famed town with its canals and bridges, cobblestone streets and rows of houses with gabled roofs, its market and béguinage, a home of Flemish nuns and a center of lace making.

Raphael distinguished himself in manner and dress from the many artists who congregated there. The Flemish critic J. Jennekens called him 'Joe Rap' and wrote: "Think about it: he doesn't wear long hair, not velvet pants, nor wide-brimmed hat, nor scarf. He looks like everyman. The green vest of [Théophile] Gautier, the purple hair of Baudelaire has been out of fashion for some time and is of no interest to him. On the contrary, he shares some of their characteristics."

Jennekens, who recognized Raphael's "great talent and sense of humor," went on to describe the artist at work in the summer 1932 issue of *Gazette de Flandres*:

> He paints with a kitchen knife on three layers of canvas, securing it on the easel fearing it would collapse from the pressure of his strokes; the ordinary palette knives bend under his strong, nervous fingers and his canvas eventually could tear; his whole body is involved, enthusiastically and vigorously engaged in the creative process . . . he has read everything, lived in at least four countries and mixes three languages; his is full of ideas to work on, and one feels that his sense of humor could be considered cruel if he were not so humane . . . Just look at his sketch of the quai: a picturesque poem done with finesse.

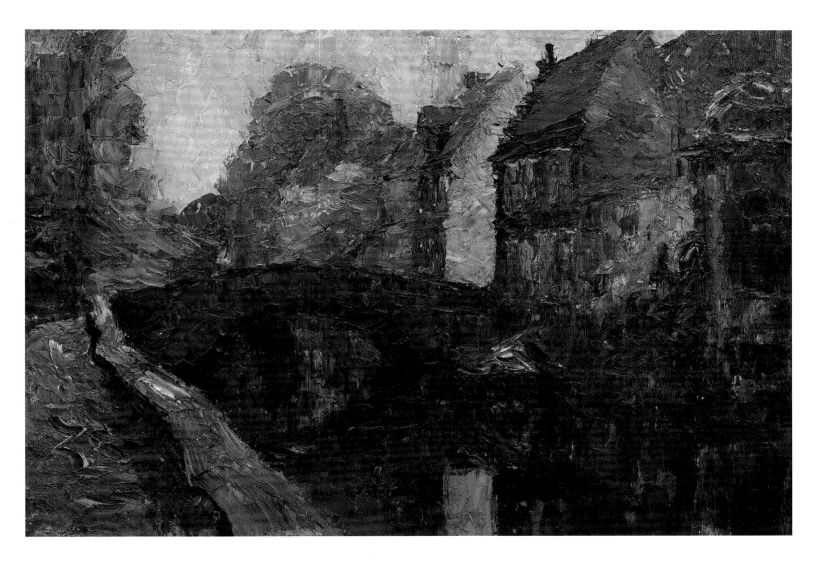

49.

Bruges in Autumn, 1932

Oil on panel
19½ × 28 inches
Signed lower right: *Joe / Raphael*

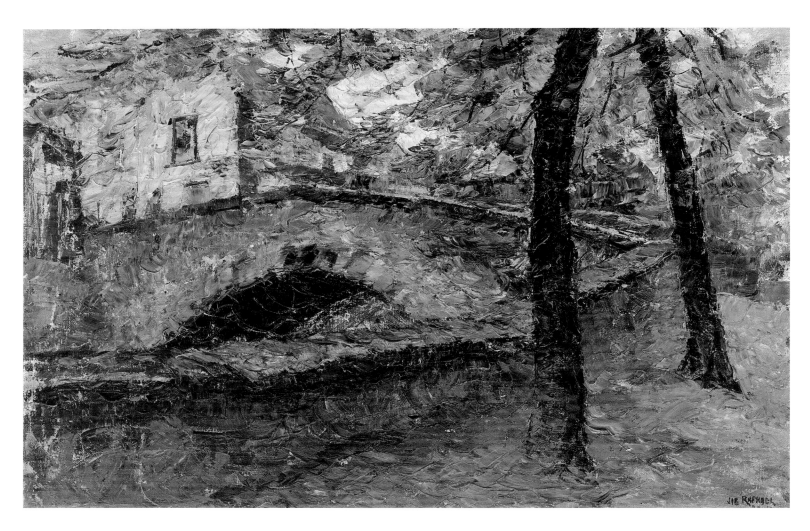

50.

Pont de Cheval, Bruges, ca. 1932

Oil on canvas
19⅛ × 29 inches
Signed and inscribed lower right: *Joe Raphael /*
Bruges / Pont de Cheval
Private Collection

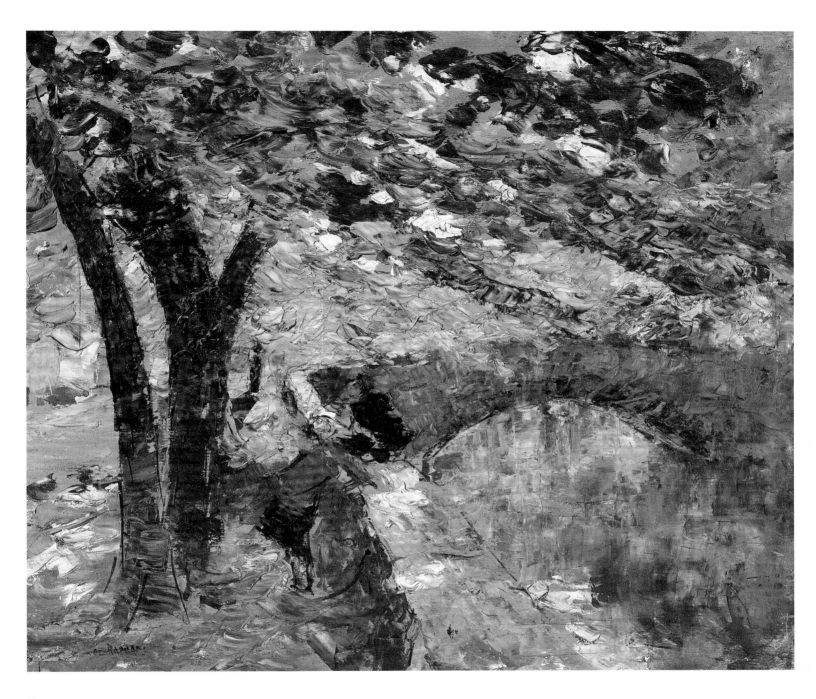

51.

Canal and Bridge, Autumn (Bruges), ca. 1932

Oil on board
16⅜ × 19¼ inches
Signed lower left: *Joe Raphael*
Private Collection

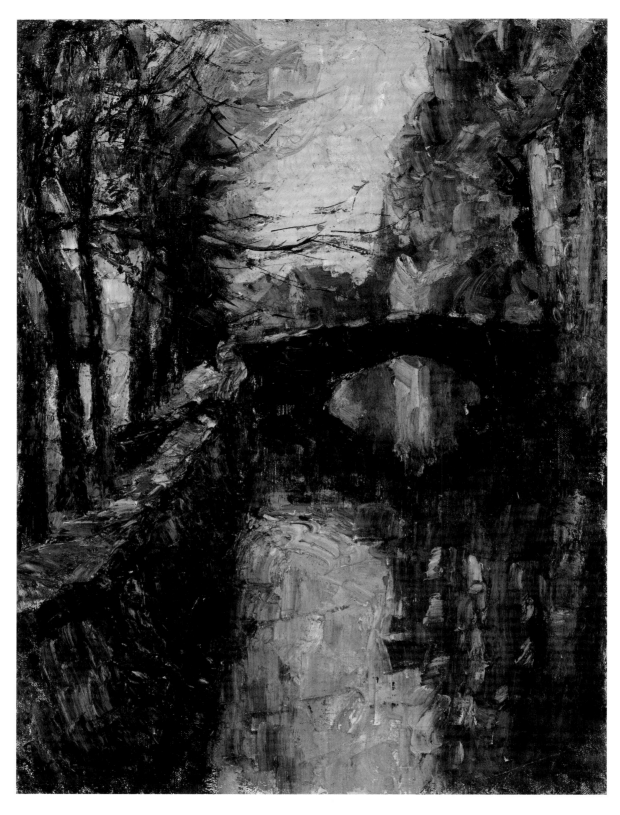

52.

Pont Romnel, Bruges, ca. 1932

Oil on canvas
29½ × 21¾ inches
Signed lower left: *Joe. / Raphael / Bruges*
Oltman Retirement Plan, Long-term loan to Pasadena
Museum of California Art

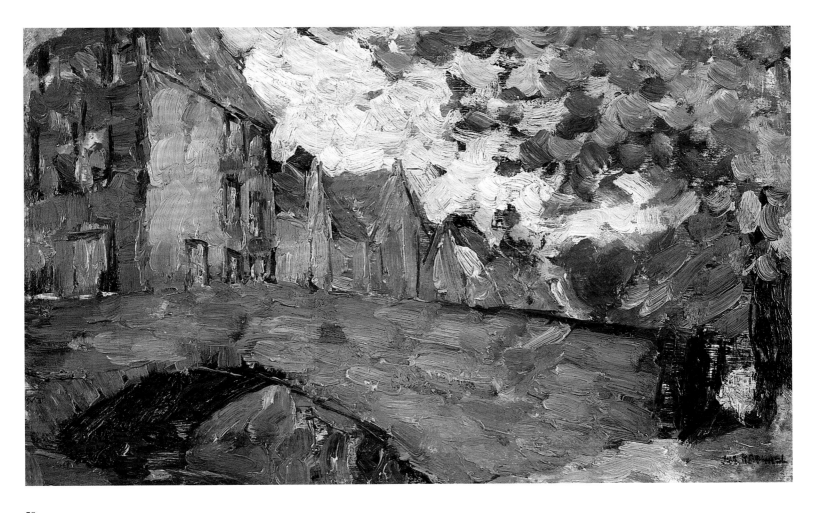

53.

Groene Rei, Brugge, 1932

Oil on board
8¾ × 13½ inches
Signed lower right: *Jos. Raphael*; signed with the artist's
monogrammed initials, dated, and inscribed on verso:
Groene Rei / Brugge. 1932. / JR

VII.

RETURN TO AMERICA, SAN FRANCISCO
AND YOSEMITE NATIONAL PARK, 1939–50

WARNED OF growing hostilities toward Jews in Europe by his devoted friend and patron, Albert Bender, and others back home in San Francisco, Raphael sailed from Holland to America in February of 1939, thankfully in time. Doubtless his yearning to return to his native country, to paint the California landscape lit by the soft intensity of its light, so different from the dark and dreary wintry months of war-ready northern Europe, played a central role as well. Raphael's artistic imagination was ready to be rekindled by the views of San Francisco's streets and Golden Gate Park. He painted the park's Japanese Tea Garden in a series of increasingly abstract compositions, and ultimately, he camped in Yosemite National Park, where he strove to capture the natural grandeur of Half-Dome and its nearby falls.

Raphael's final years back home in California brought out the Modernist painter in him: he now incorporated all of his talent as an assured draftsman who could portray his subjects through keen and direct observation with equal facility of line and color. His brushwork became even more robust and multilayered and reflective of his powerful hand. His creative forces were at their peak. His personal Impressionist style richly encompassed key aspects of subsequent artistic movements.

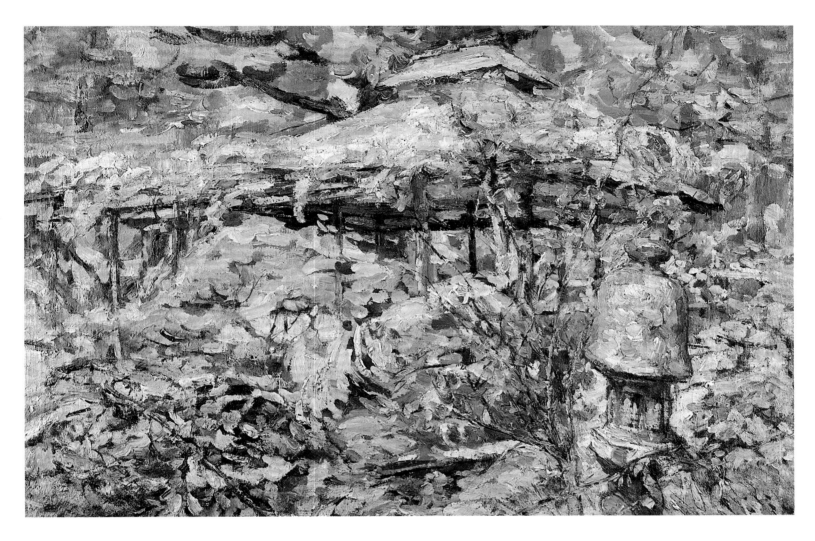

54.

Japanese Tea Garden with Lantern,
Golden Gate Park, San Francisco, ca. 1940–45

Oil on canvas
23½ × 36¼ inches

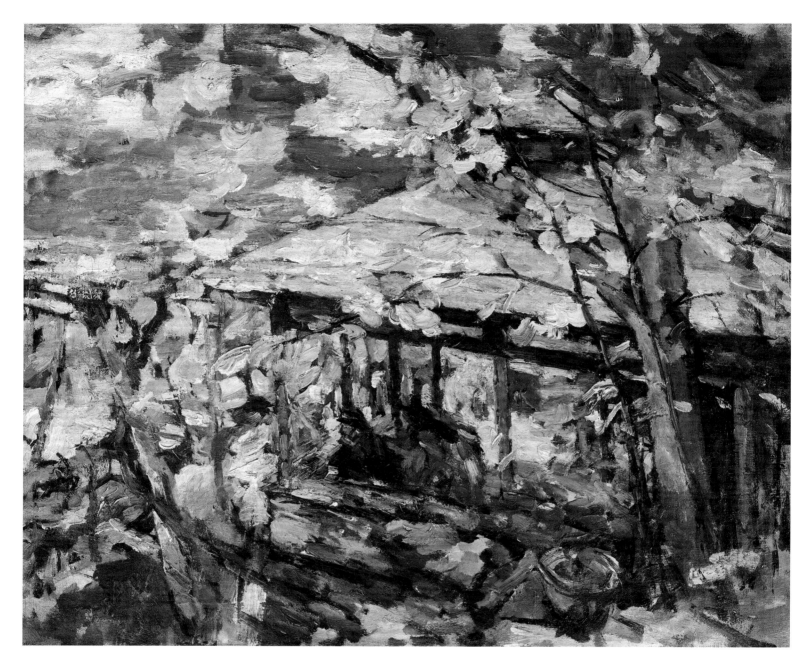

55.

Japanese Tea Garden with Tea House,
Golden Gate Park, San Francisco, ca. 1939

Oil on canvas
21⅝ × 25⅝ inches
Private Collection

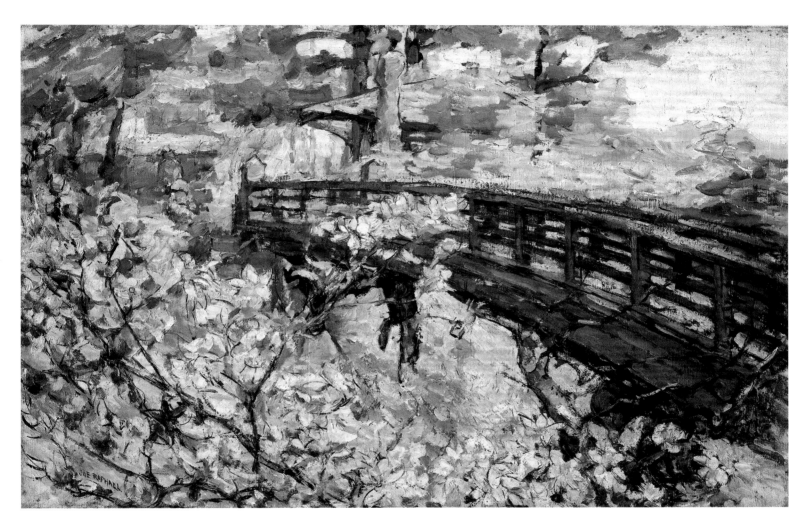

56.

Bridge, Japanese Tea Garden, Golden Gate Park,
San Francisco, ca. 1940–45

Oil on board
26 × 40 inches
Signed lower left: *Joe Raphael*
Private Collection

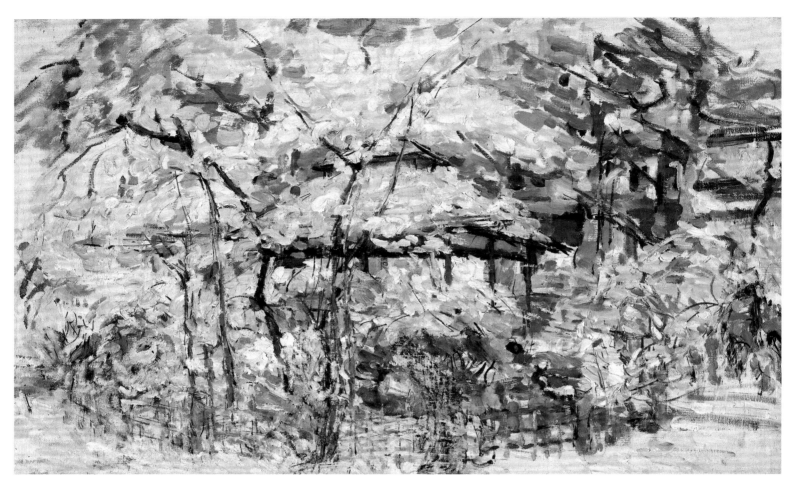

57.

Trees, Japanese Tea Garden, Golden Gate Park, ca. 1940–45

Oil on canvas
28½ × 47 inches
Signed lower left: *Joe Raphael*
Private Collection

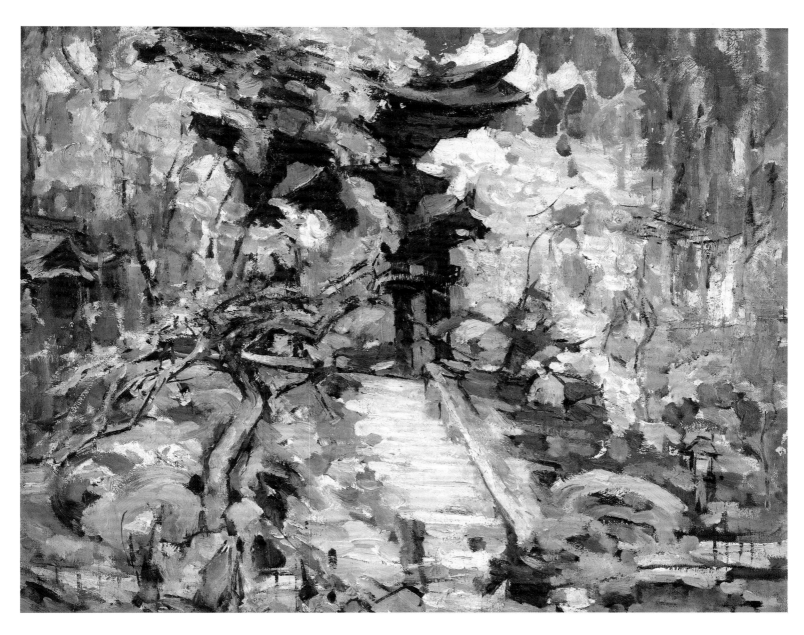

58.

*Japanese Tea Garden, Golden Gate Park,
San Francisco,* ca. 1940–45

Oil on canvas
23⅝ × 29½ inches
Oscar and Trudy Lemer Collection

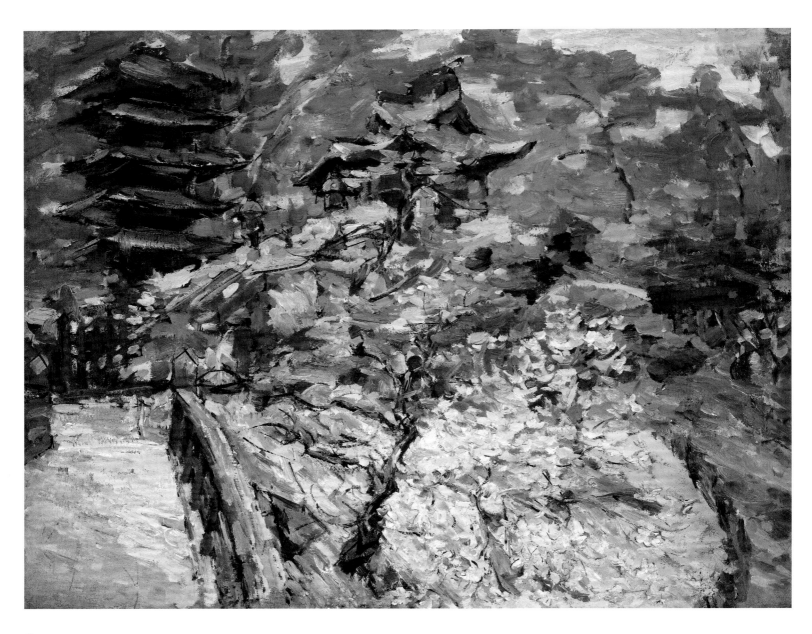

59.

Pagodas in the Japanese Tea Garden,
Golden Gate Park, ca. 1940–45

Oil on canvas
28⅛ × 35¼ inches
Oltman Retirement Plan, Long-term loan to
Pasadena Museum of California Art

60.

Lighthouse at Mouth of San Francisco Bay, ca. 1942

Gouache on board
22 × 28 inches
Private Collection

61.

Fishermen, San Francisco Bay, ca. 1946

Watercolor on paper
18⅞ × 24¾ inches
Private Collection

62.

Turtles and Fish in the Aquarium,
Golden Gate Park, ca. 1942

Gouache and watercolor on paper
25 × 38 inches
Signed lower right: *Joe Raphael*
Private Collection

63.

A Bear at Yosemite Lodge, ca. 1950

Graphite under pen and ink, watercolor,
and oil on paperboard
20 × 29⅞ inches

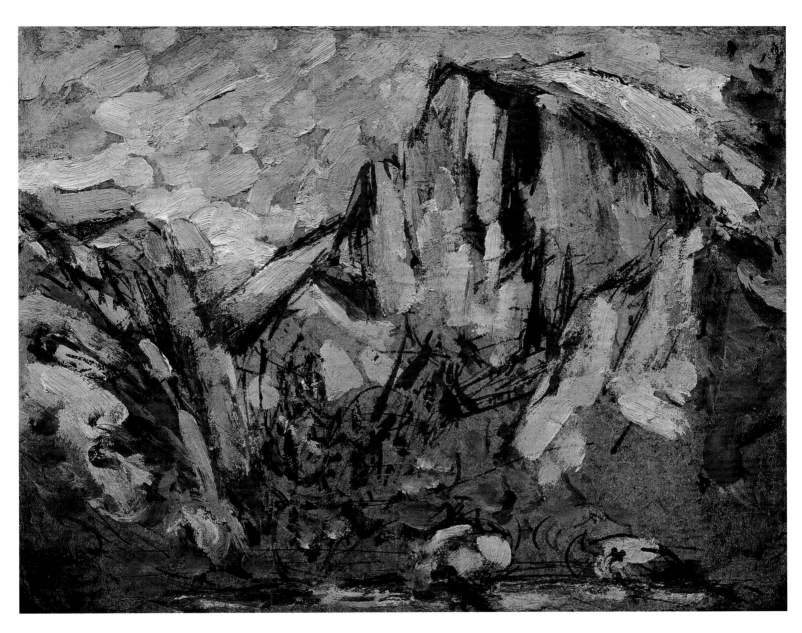

64.

Half-Dome, Yosemite, ca. 1950

Pen and ink and oil on board
10¼ × 12⅝ inches
Private Collection

VIII.

RAPHAEL'S GRAPHIC OEUVRE, 1912–50

RAPHAEL was as skilled with pen and pencil as with paint and brush. In Brussels, from 1912 to 1923, he applied his able hand to etching outdoor scenes and occasional views from daily life.

By the mid-1920s, he began "cutting wood—using the Krieken stams (cherry trunks, Dutch) from my garden and a knife of some sort." Raphael explained: "Just worked it out myself (those whom I applied to for help turned me down). I spoiled a good lot of paper and ink trying to get the paper off the block (and do so still)—use *one* little tool for cutting." In an autobiographical letter that Raphael wrote in July 1933 to the Dutch critic, Albert Plasschaert, he recalled:

> Later on [I studied] several books on Japanese woodcutters in Leiden, with its splendid prints, and yes, in Brussels, with its collections of Japanese prints. I swallowed everything in over twenty years or more on everything that has been published on Japanese prints from the de Goncourts to the Smithsonian Institute. I tell you this not because I am an erudite in Japanese art but simply because a Japanese print gives me great pleasure, apart from its historical interest.

With few exceptions, Raphael limited himself to black and white until his return to San Francisco in 1939. There, inspired by the views of the city and, with the art gallery in Gump's Department Store selling as many of his color woodcuts as he could produce, he printed compositions of oblique angles and syncopated rhythms. These vividly colored prints, reinforced with pastel and painted or powdered pigments, were created by an artist who was over seventy years old on the floor of his one-room apartment. They sometimes took him as long as "twenty-five hours of intense application—killing work." (Raphael, San Francisco, July 16, 1945, to his wife, Johanna, Oegstgeest, Holland, Raphael Catalogue Raisonné Archives).

Alfred Frankenstein, the renowned art and music critic, wrote in the *San Francisco Chronicle* on January 14, 1951: [Raphael's color woodcuts] "remain among the most individual and inventive works of their kind, which any American has produced . . . his woodcuts are swift and swoopy, combining the sparkle of the offhand sketch with the black dramatic forms of the block print."

65.

Raphael's Wife Nursing Her Infant Son, Piet, 1912

Graphite, charcoal, and pastel on board
11½ × 9½ inches
Dated and inscribed lower right: *Waarschijnlijk Piet, Rue de la /
Station / 1912*
Oscar and Trudy Lemer Collection

66.

Zoute (Belgium), ca. 1920

Pen and ink on paper
17 × 25¾ inches
Signed and inscribed lower left: *Zoute / Joe Raphael*

67.

Amsterdam Jewish Quarter with South Church, 1928

Etching
11½ × 16¼ inches (plate)
Signed, dated, and inscribed lower left below plate:
Amsterdam Jewish Quarter 1928 / Joe Raphael.
Mort and Donna Fleischer Collection

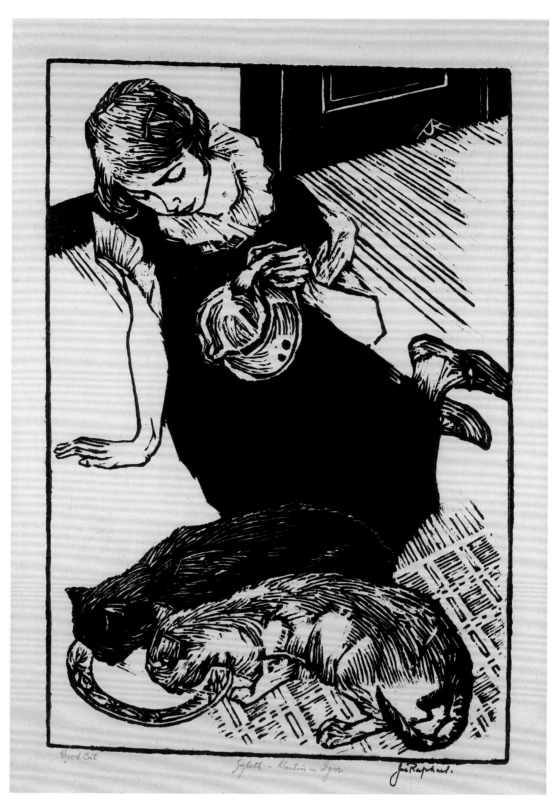

68.

Artist's Daughter (Liesbeth) with Cats, ca. 1926

Woodcut in black ink on paper
13¾ × 9 inches (image); 21 × 14¼ inches (sheet)
Signed with monogram in image upper right: *JR*; Signed below image
lower right: *Joe Raphael.*; inscribed below image lower left: *Wood Cut*;
inscribed below image lower center: *Lizbeth-Martin-Igor*
Mort and Donna Fleischer Collection

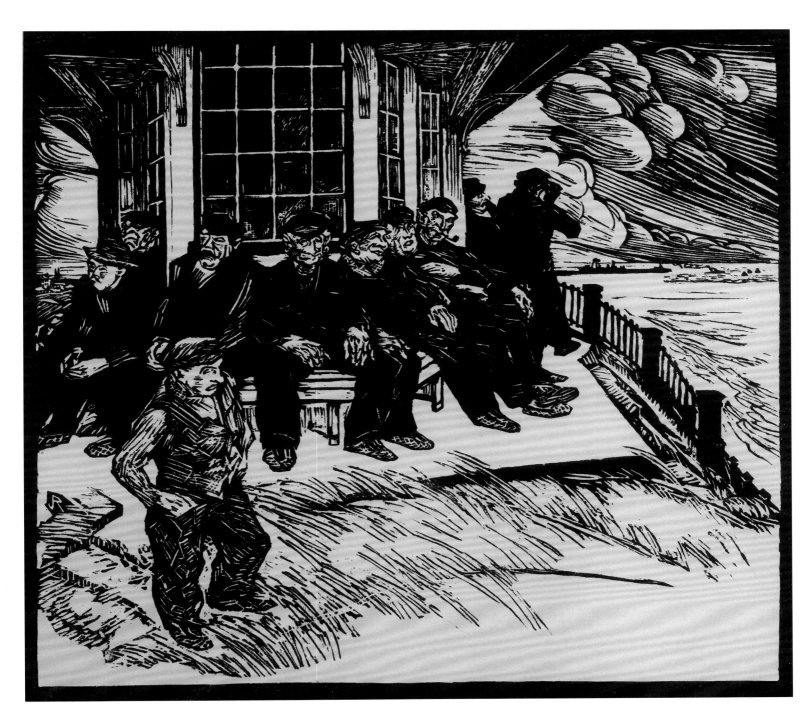

69.

*Pavilion in the Dunes, Zeemans Home,
Breedene-Ostend, II (Belgium)*, 1927

Woodcut in black ink on paper
16⅛ × 17¾ inches (image); 17 × 23 inches (sheet)
Signed with monogram in image lower left: *JR*;
Signed below image lower right: *Joe Raphael*; signed and inscribed
below image lower left: *Pavillion in the Dunes—Zeemans Home
Breedene-Ostende / J. Raphael*
Private Collection

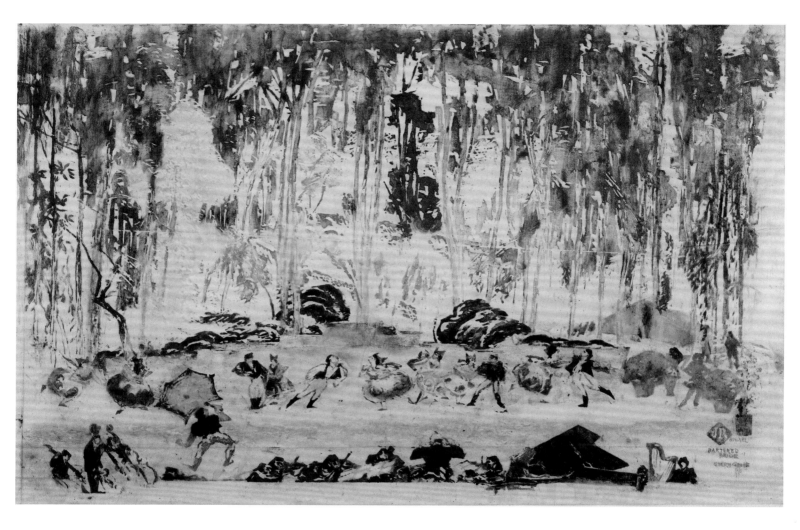

70.

Bartered Bride, Stern Grove (San Francisco), 1940

Color woodcut with hand coloration on rice paper
12¼ x 18⅞ inches (sheet)
Stamped with the artist's initials lower right: *JR*; signed, dated, and
inscribed lower right: *Raphael / Bartered / Bride / Stern Grove / 40*
Private Collection

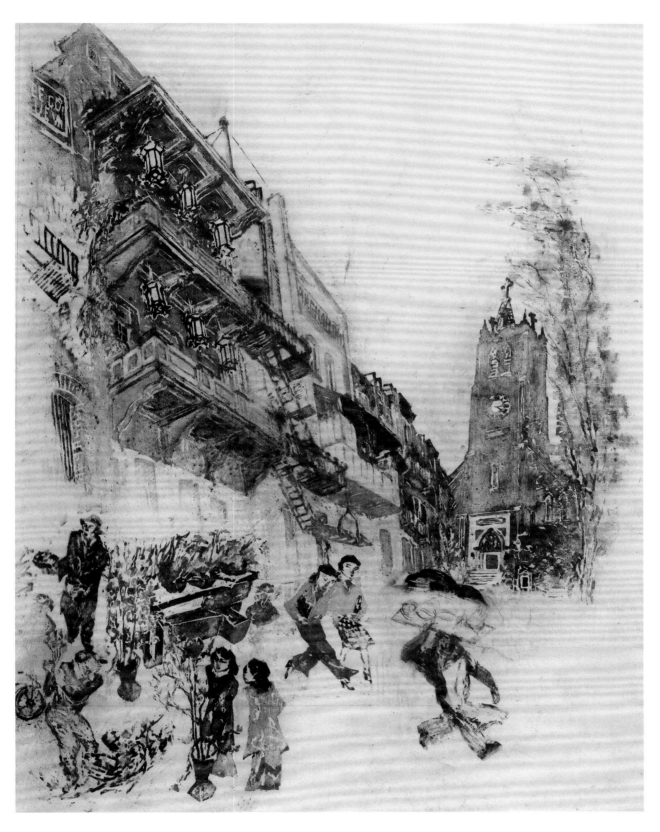

71.

Quincy Street and Old St. Mary's Church, San Francisco, ca. 1947

Color woodcut with hand coloration on board
19⅛ × 14½ inches (sheet)
Private Collection

72.

Corsages, Grant Avenue, San Francisco, ca. 1946

Color woodcut with hand coloration on paper
19 × 14½ inches (sheet)
Stamped with the artist's monogram lower left: *JR*;
signed and inscribed lower left: *Joe / Raphael / -Corsages- / Grant Avenue*
Private Collection

73.

California and Stockton (San Francisco), ca. 1945

Color woodcut with hand coloration on mulberry paper
17¾ × 17½ inches (image); 21½ × 20 inches (sheet)
Stamped with the artist's monogram lower right: *JR*; signed and
inscribed lower right: *Joe Raphael / California / + Stockton / To Sox / + Dan*
Mort and Donna Fleischer Collection

JOSEPH RAPHAEL—CHRONOLOGY

1869
Born June 2 in San Francisco to Nathan and Elizabeth (née Moses) Raphael.

1882
Left school to support his family by working in a San Francisco store. Then moved with his family to Amador City, Sierra Nevada foothills, where he washed gold for a mining company.

1884
Moved with his family to Arizona Territory, where he worked in a trading post.

1887
Moved back to San Francisco; attended evening classes with Norwegian-born Christian Jorgensen (1860–1935) and Austrian-born Solly Walter (1846–1900).

1893
Enrolled at California School of Design (now, the San Francisco Art Institute), part of the San Francisco Art Association, where he studied life drawing and painting with Arthur F. Mathews (1860–1945) and modeling with sculptor Douglas Tilden (1860–1935).

1894
Received the W. E. Brown Medal and Scholarship for Life Drawing from the Mark Hopkins Institute of Art, also part of the San Francisco Art Association.

1895
September—first known exhibition, at State Agricultural Society, Sacramento.

1896
December—first exhibited at Mark Hopkins Institute of Art and San Francisco Art Association.

1897
Awarded the James E. Phelan gold medal for modeling from life from the Hopkins Institute.

1900
Worked as a sign painter for Hiram Walker Whiskey.

1903
Went to Paris; enrolled at Académie Julian, under Jean-Paul Laurens (1838–1921). Associated with other American artists who met in the studios of the Pittsburgh painter Arthur Sparks (1870–1919) and the Canada-born, California-raised William Clapp (1879–1954).

July 29—first visited Laren, Holland; stayed at the Pension Kam. During the next nine years, divided his time between Paris and Laren

1904
Resided in Laren at the home of the van Eiden family with American artist friend, Ralph F. Mocine.

First exhibited at the Paris Salon.

1905
May—traveled from Paris through Italy with five other American artists, including Kansas-born Albert Krehbiel (1873–1945); visited Rome, Pisa, Florence, and Venice.

November—visited museums and galleries in Amsterdam with Krehbiel.

1906
March—visited the Forest of Fontainebleau, with Krehbiel and Ohio-born Wilder Darling (1856–1933).

April—traveled through Spain, visiting art museums, with Krehbiel and Darling.

Received an honorable mention from the Paris Salon for *The Bourgmestre* (Cat. 1).

1909
Began correspondence with Albert M. Bender, San Francisco insurance broker and art patron.

1910
January—returned to San Francisco, stayed eight months.

February—one-man exhibition of forty-five paintings held at the San Francisco Institute of Art (now San Francisco Art Institute).

Fall—visited Los Angeles, Mexico, New York, and Havana, Cuba, before returning to Laren at the end of the year.

1911
May 29—married Johanna Jongkindt, a pianist and mother of Catherine, age three.

1912
January— moved from Laren to Uccle, a suburb of Brussels. Lived in a rental home on Rue de la Station.

January 18—birth of Pieter (Piet) Nicholaas Raphael, the artist's first child and only son.

April—last recorded visit to Laren.

Summer—first exhibition at Helgesen's Gallery, San Francisco, included etchings.

1913
December—exhibited at California Society of Etchers (along with Ralph Stackpole, Armin C. Hansen, and Frank Van Sloun)

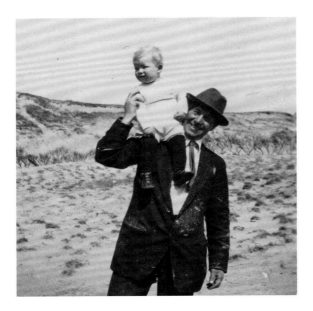

Fig. 15.
Photograph of Joseph Raphael and his son,
Pieter Nicholaas, 1912, Uccle, Belgium, courtesy of
Johanna Raphael Sibbett.

1914
April 22—birth of Elizabeth (Liesbeth), the artist's second
child.

August—Raphael's work interrupted by the German invasion
of Belgium at the start of World War I

1915
Purchased land and built a small house on rue Engeland,
in Kriekeput (Dutch for "Cherry Valley"), south of Uccle
village, with views of Linkebeek Village to the southeast and
Papekasteel ("Pope's Castle") to the west.

February—participated in the Panama-Pacific International
Exposition, San Francisco; received silver medal for *Spring
Winds* (Cat. 11).

1916
Received first purchase prize and gold medal for *The Garden
Path* (Fig. 8) at California Artists, San Francisco Art
Association.

1918
March 3—birth of Marie-Jeanne (nicknamed Dany or
Danny), the artist's third child.

1919
August 25—birth of Johanna Irène (nicknamed Joke), the
artist's fifth and last child.

1920
September—received visit from San Francisco painter-friend,
Gottardo Piazzoni.

1922
May—built a studio onto his house at Uccle.

1923–24
Received Los Angeles History, Science, and Art Purchase Prize
for *The Japanese Doll* (1916; private collection) at the *Third
Annual Traveling Exhibition of Selected Paintings by Western
Artists*, Los Angeles Museum of History, Science, and Art.

Began creating woodcuts.

1927
Summer—vacationed with his family in Ostende, on the
Belgian coast.

1928
January—awarded prize for *Belgian Trawlers* (private
collection) in *Fiftieth Annual Exhibition of the San Francisco
Art Association.*

August—vacationed with his family in Leiden, Holland.

1929
January—one-man exhibition at Valdespino Gallery,
San Francisco.

May–June—spent two months at Villa Faraldo in Menton, on
the French Riviera. Painted almost exclusively in watercolor.

Summer—moved to Oegstgeest, Holland, a suburb of Leiden,
twenty minutes by tram from the North Sea.

1930
January—fire in Valdespino Gallery destroyed works by
Raphael; the artist received a six-thousand-dollar insurance
payment.

1931
Began to visit Kagermeer (Kaag Lake), Holland, where he
recorded scenes of sailing vessels.

1932
Summer and fall—spends time painting in Bruges, Belgium.
1933
January—Oakland Art Gallery held one-man exhibition,
*Paintings by Joseph Raphael: One of America's Greatest
Impressionists.*

Summer—joined his wife in St. Marguerita on the Italian
Riviera, where she was hospitalized.

1938
Summer—Raphael and his wife vacationed in Cannero on
Lago Maggiore, Italy. Visited Venice and Lake Como on their
return to Oegstgeest.

1939
February—traveled alone by boat from Rotterdam to New
York and by bus to San Francisco. Rented a small studio
apartment in Wall Hotel, at the corner of Bush and Franklin,
above Hermann's Market (owned by his brother-in-law).

May—daughter Marie-Jeanne joined her father in San
Francisco.

October—Raphael's woodcuts sold at Gump's Department
Store, San Francisco.

December 15–31—exhibition of paintings and prints by
Raphael held at San Francisco Museum of Modern Art.

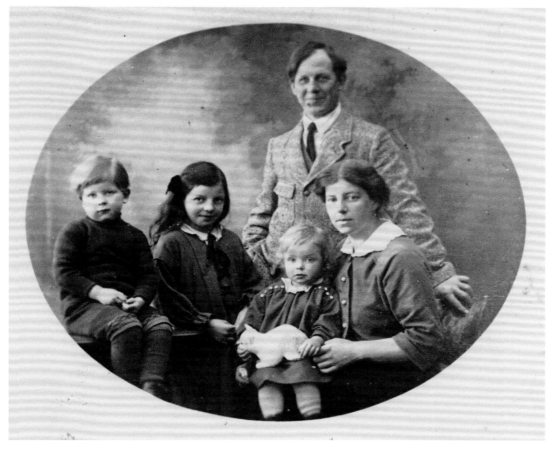

Fig. 16.
Photograph of Joseph Raphael, his wife, Johanna Jongkindt, and children (from left), Pieter Nicholaas, Catherine, and Elizabeth (Liesbeth), ca. 1915–16, courtesy of Johanna Raphael Sibbett.

1940
Participated in the Golden Gate International Exposition, World's Fair on Treasure Island, San Francisco.

1941
March 4—death of Albert M. Bender.

April—last exhibition of Raphael's work at Helgesen's.

1942
Took a job in a machine shop, producing motors for seagoing ships; then took a position cleaning optical equipment for the navy at the California Academy of Sciences; took lunch breaks to paint large gouaches of marine animals and fish at the Steinhardt Aquarium in Golden Gate Park.

1945
Raphael's wife Johanna died of a heart attack in Oegstgeest, age sixty-three.

1946
April—quit job to return to his art full-time.

Daughter, Johanna, joined her father in San Francisco.

1949
November—daughters Liesbeth and Catherine joined their father in San Francisco for extended visit.

1950
April—visited Yosemite.

May–October—made a second and extensive visit to Yosemite.

December 11—died at eighty one in San Francisco's Maimonides Hospital, after unsuccessful surgery for colon cancer.

1951
January—memorial exhibition of Raphael's paintings and woodcuts held at San Francisco Museum of Modern Art.

INDEX TO ILLUSTRATIONS